WILD PALETTE

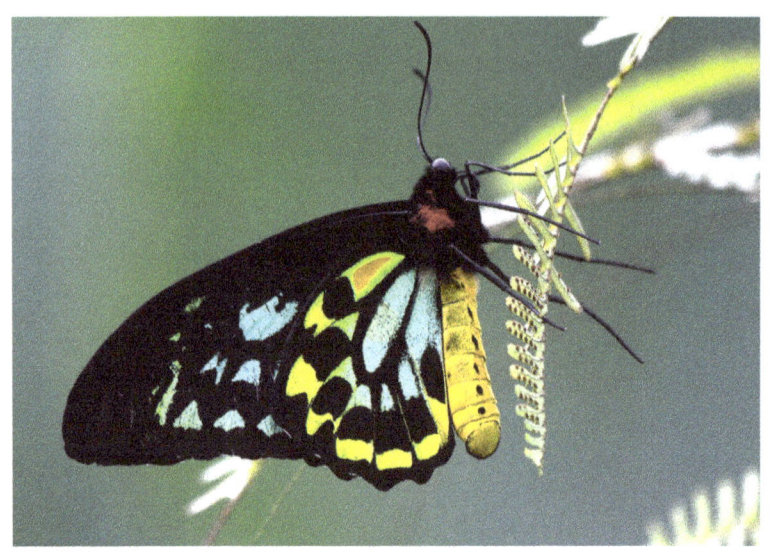

Cairns Birdwing
Ornithoptera euphorion

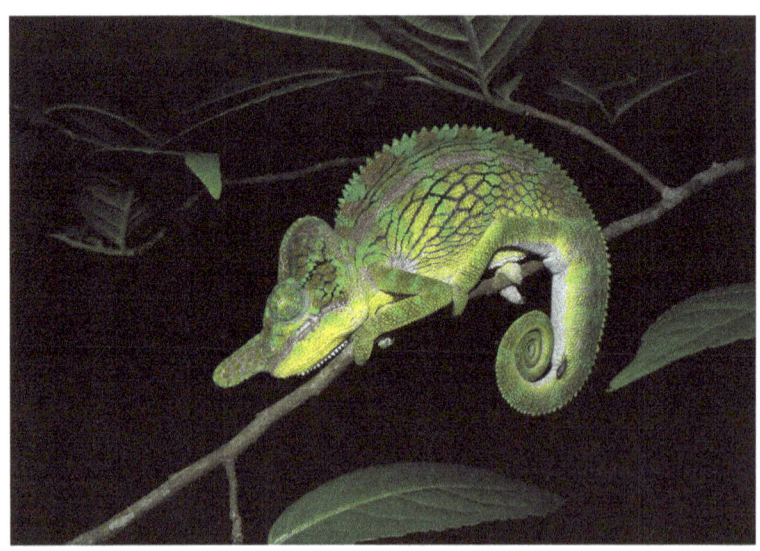

Labord's Chameleon
Furcifer labordi

WILD PALETTE

Wildlife-Inspired Color Combinations for Creature Modeling, Interior Design, and Artistic Exploration

CHAD ARMENT

COACHWHIP PUBLICATIONS
Greenville, Ohio

Wild Palette
© 2019 Coachwhip Publications

Cover images: (front) Crimson-Collared Tanager (CC-BY) Andy Morffew; Baltimore Checkerspot (CC-BY) Judy Gallagher; (back) Katydid, *Elephantodeta* sp. (CC-BY) Jean and Fred; Variable Neon Slug (CC-BY) Elias Levy; Redspot Sawtooth butterfly (CC-BY) Zleng.

CoachwhipBooks.com

ISBN 1-61646-489-5
ISBN-13 978-1-61646-489-9

INTRODUCTION

Colors have purpose in living organisms. Whether hunter or hunted, many species adapt in coloration and pattern to their environment. Others exhibit colors for signaling, including warning predators away or attracting mates (the latter perhaps developing only seasonally). Other uses for coloration include thermoregulation, mimicry, predator distraction, and inter-specific communication.

Coloration is not static. Lighting plays its part (especially with reflective or iridescent scales and shells), while some pigment-bearing cells (chromatophores) change colors in response to the environment. In mammals, some colors and shades are created when two or more hair colors are combined. Texture may determine whether a color is matte or glossy. Extremes in coloration include transparency (glass fish or clearwing moths), bioluminescence (fireflies and deep-sea fish), and shifting colors (cephalopods and chameleons).

All visible colors can be found in living organisms—as can colors we can't see. Humans are trichromats, allowing us to see most visible colors by having red, green, and blue cone receptors in our eyes. Some mammals, like dogs, are dichromats, having only two kinds

of cone receptors. Certain fish, birds, and insects have four or more types of cone receptors (including receptors for ultraviolet light). Snakes that have 'pit organs' can 'see' infrared. For organisms that lack certain color receptors, luminance and contrast may be as important as coloration itself.

This booklet will hopefully inspire readers' artistic endeavours as they examine common color combinations in wildlife and consider why they might be that way. Certainly, there are cases of incidental coloration, but even then, there usually is a logical basis for such appearance, even if the coloration itself is not intentional.

One caveat with this booklet: it is printed in a CMYK (cyan, magenta, yellow, black) color space, which cannot replicate the entire RGB color spectrum—bright reds, greens, and blues are not possible. Still, you should be able to extrapolate potential compatibilities using the following color schemes. Note, of course, that not all colors in a palette are equally expressed by an organism and there may be significant differences between individuals within the same species.

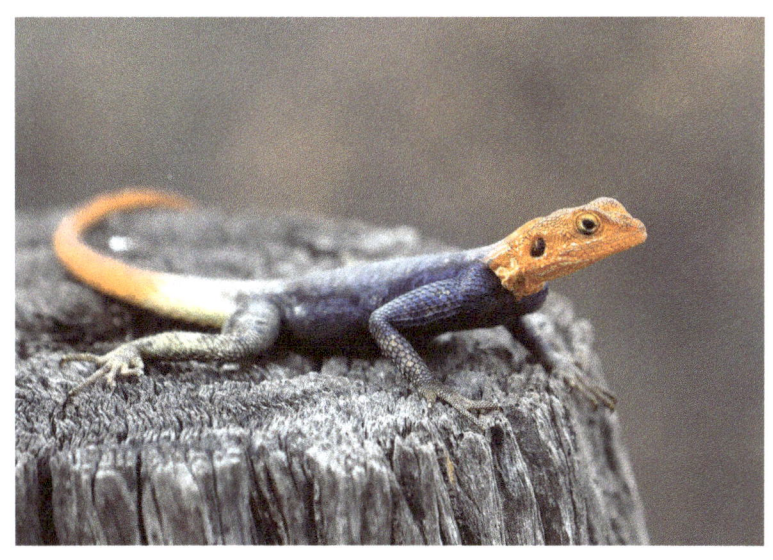

Namib Rock Agama, males court females
with colorful head-bobbing displays
Agama planiceps

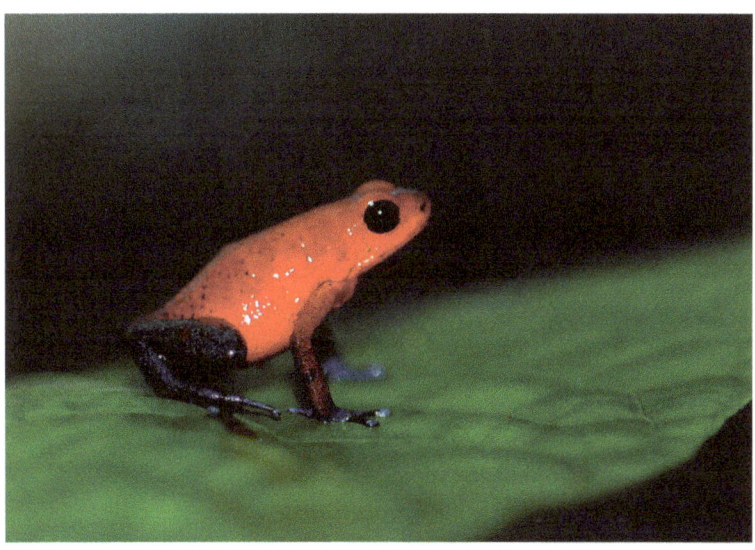

Strawberry Poison-Dart Frog with warning coloration
Oophaga pumilio

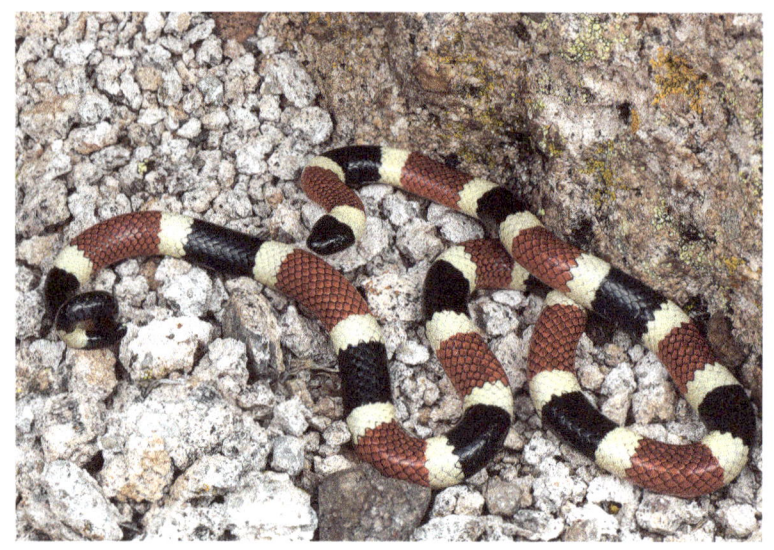

Sonoran Coral Snake, venomous with warning colors
Micruroides euryxanthus

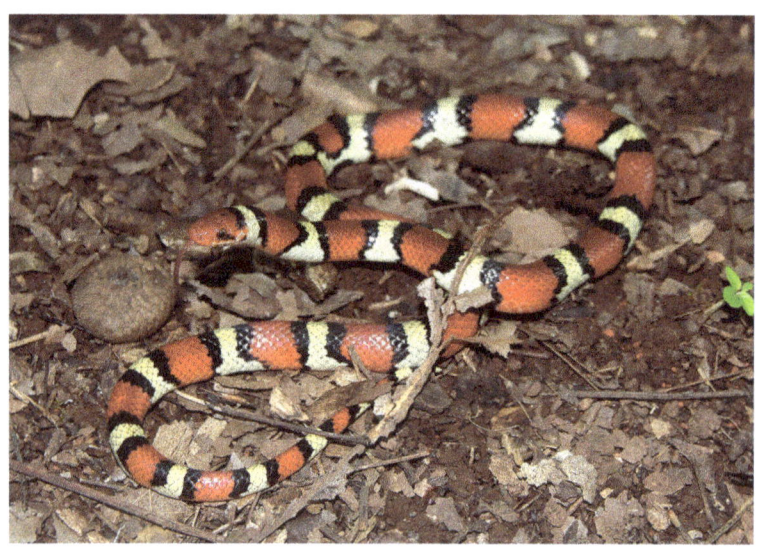

Scarlet Kingsnake, harmless coral snake mimic
Lampropeltis elapsoides

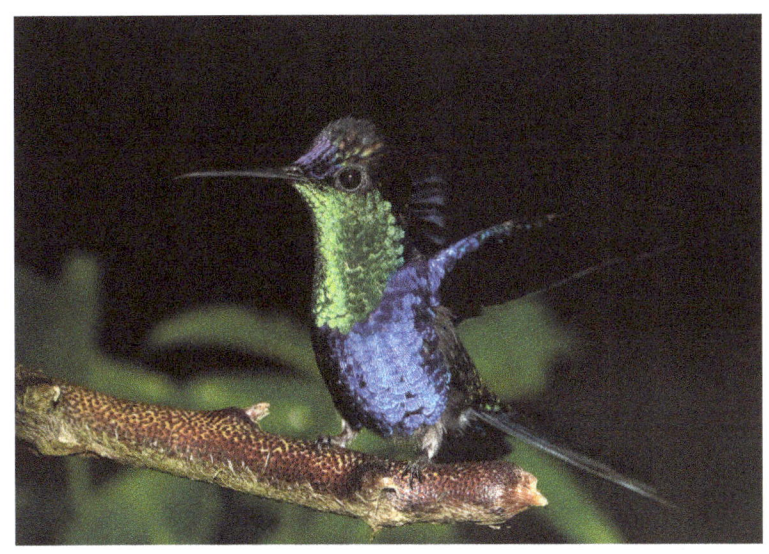

Violet-Crowned Woodnymph with iridescence
Thalurania colombica colombica

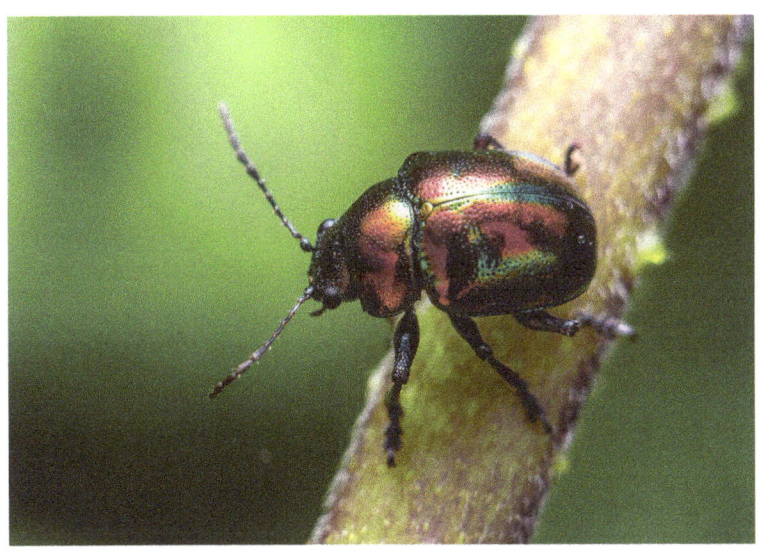

Beetle with iridescence
(Coleoptera)

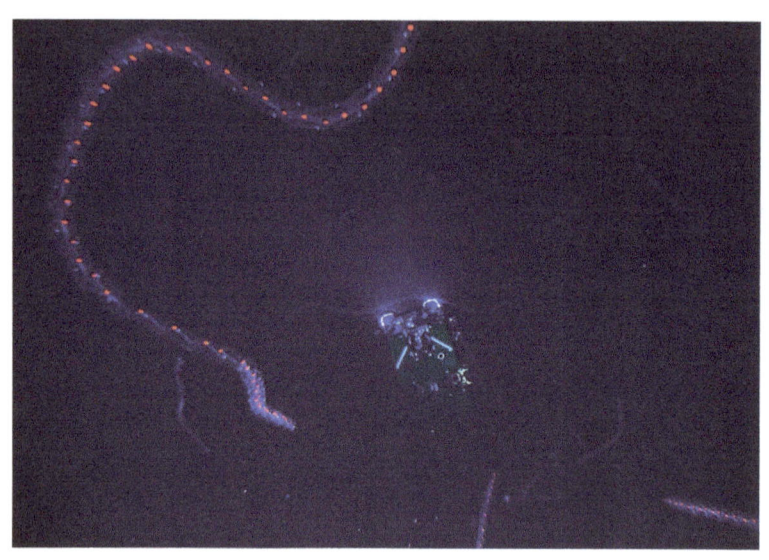

Siphonophores with bioluminescence
(Siphonophorae)

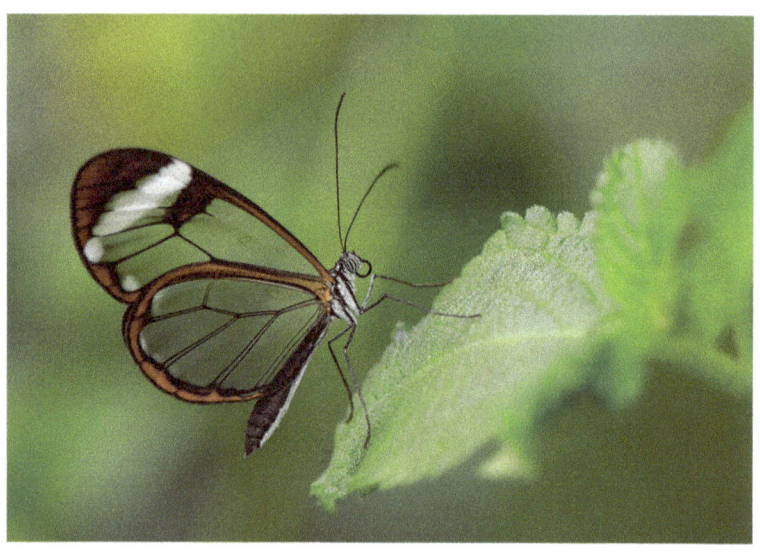

Glasswing Butterfly showing transparency
Greta oto

Two Colors

One of the most common two-color combinations is simply white and black. The contrast breaks up an animal's outline and, when moving in groups, can make it difficult for predators to single out an individual. (In skunks, it can even be a warning display.)

EXEMPLARS:
Chinstrap Penguin
Pygoscelis antarcticus

Giant Panda
Ailuropoda melanoleuca

Plains Zebra
Equus quagga

Striped Skunk
Mephitis mephitis

White-Striped Black Moth
Trichodezia albovittata

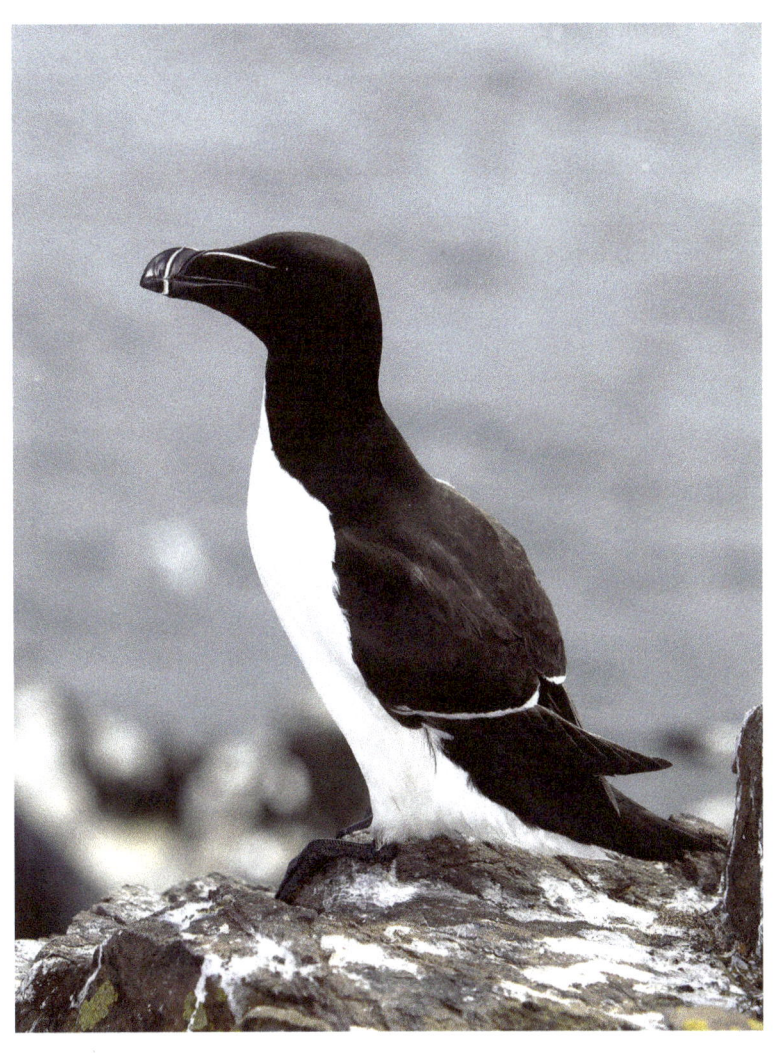

Razorbill
Alca torda

A species exhibits countershading when it is darker above and lighter below. This especially camouflages the animal when seen from above (viewed against a darker background) or from below (viewed against a lighter background).

Distractive markings are usually small, drawing attention away from the animal's outline. Other species use disruptive markings, which break up the outline itself.

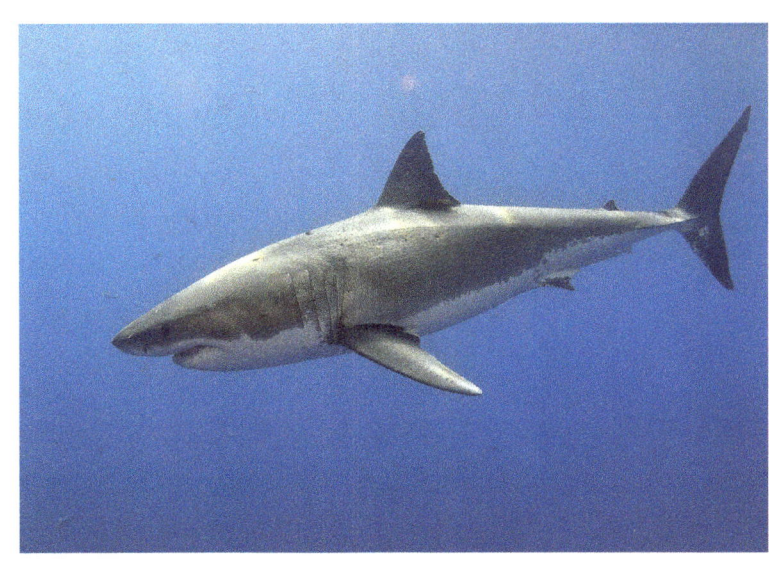

Great White Shark
Carcharodon carcharias

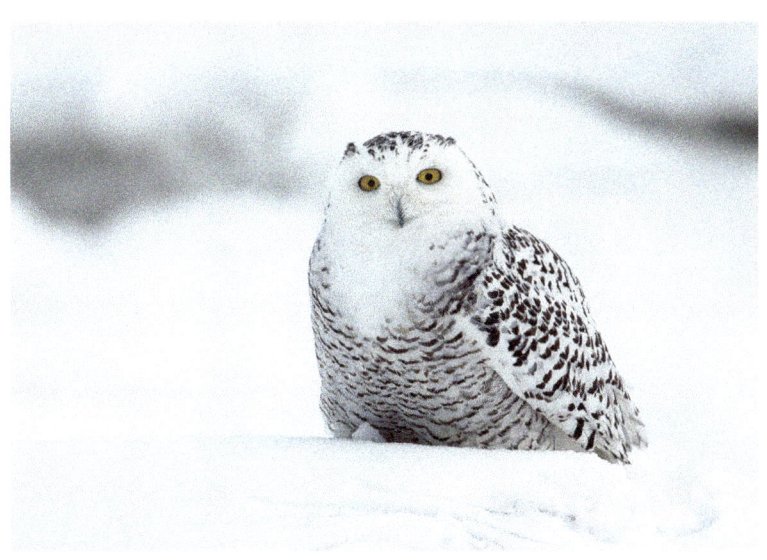

Snowy Owl
Bubo scandiacus

Mud Salamander
Pseudotriton montanus

Bamboo Ratsnake
Oreocryptophis porphyraceus

Ringed Python
Bothrochilus boa

Scarlet Tanager
Piranga olivacea

Mud Snake
Farancia abacura

Gila Monster
Heloderma suspectum

Cinnabar Moth
Tyria jacobaeae

Eurasian Golden Oriole
Oriolus oriolus

Mangrove Snake
Boiga dendrophila

Long-Tailed Salamander
Eurycea longicauda

Green and Black Poison-Dart Frog
Dendrobates auratus

Mangshan Pit Viper
Protobothrops mangshanensis

Steller's Jay
Cyanocitta stelleri

Red Caecilian
Uraeotyphlus oxyurus

Pink Robin
Petroica rodinogaster

Copperhead
Agkistrodon contortrix

Broadhead Skink
Plestiodon laticeps

Crested Gecko
Correlophus ciliatus

Fire-Belly Newt
Cynops orientalis

Ensatina Salamander
Ensatina eschscholtzii

Bi-Colored Caecilian
Epicrionops bicolor

Rosy Maple Moth
Dryocampa rubicunda

Fairy Basslet
Gramma loreto

Strawberry Poison-Dart Frog
Oophaga pumilio

Blue and Red Harlequin Beetle
Tectocoris diophthalmus

Namib Rock Agama
Agama planiceps

"El Pangan" Diablito Poison-Dart Frog
Oophaga sylvatica

Tokay Gecko
Gekko gekko

Cardinal Tetra
Paracheirodon axelrodi

Emperor Red Snapper
Lutjanus sebae

Leaf Katydid
Typophyllum lunatum

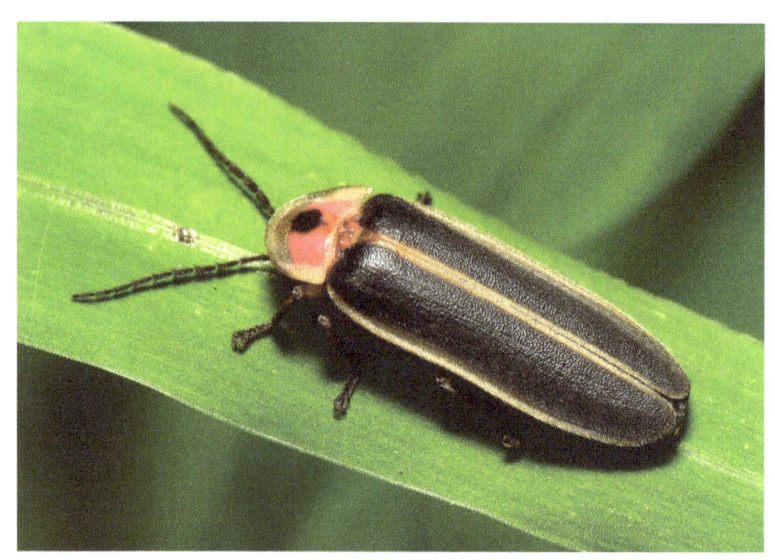

Common Eastern Firefly
Photinus pyralis

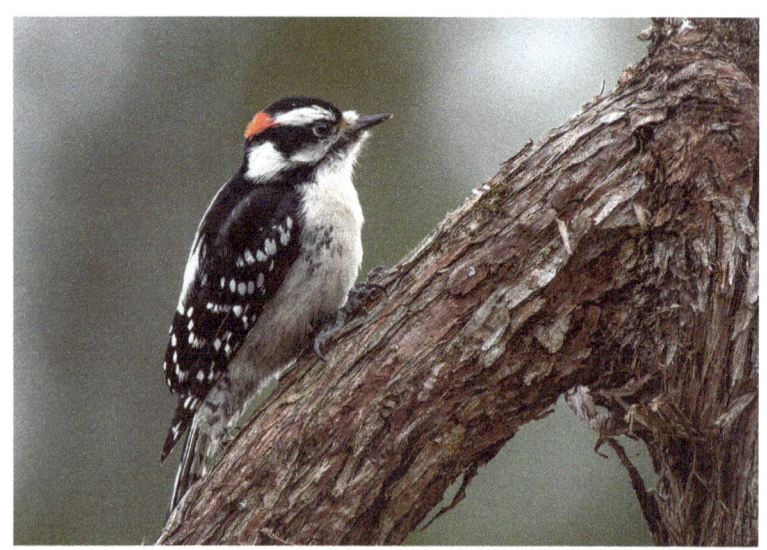

Downy Woodpecker
Picoides pubescens

Three Colors

Louisiana Milksnake
Lampropeltis triangulum amaura

Red-Headed Woodpecker
Melanerpes erythrocephalus

Red Pierrot
Talicada nyseus

(butterfly)

Red-Crested Cardinal
Paroaria coronata

Common Clownfish
Amphiprion ocellaris

Tiger
Panthera tigris

Flame-Bordered Charaxes
Charaxes protoclea

(butterfly)

Clown Triggerfish
Balistoides conspicillum

Red Postman
Heliconius erato

(butterfly)

Great Eggfly
Hypolimnas bolina

(butterfly)

Belted Kingfisher
Megaceryle alcyon

Strawberry Finch
Amandava amandava

Congo Tree Frog
Hyperolius viridiflavus

Eastern Coral Snake
Micrurus fulvius

Lemon Harlequin Toad
Atelopus sp. *spumarius* complex

Zigzag Fungus Beetle
Erotylus incomparabilis

Yellow Garden Spider
Argiope aurantia

Redbelly Toad
Melanophryniscus stelzneri

Starry Night Reed Frog
Heterixalus alboguttatus

Yellow-Headed Calico Snake
Oxyrhopus formosus

Blue-Legged Mantella
Mantella expectata

Blue-Winged Mountain Tanager
Anisognathus somptuosus

Five-Lined Skink
Plestiodon fasciatus

Superb Bird-of-Paradise
Lophorina superba

Leichhardt's Grasshopper
Petasida ephippigera

Scarlet-Bellied Mountain Tanager
Anisognathus igniventris

Jewel Beetle
Temognatha suturalis

San Francisco Garter Snake
Thamnophis sirtalis tetrataenia

Blue Malayan Coral Snake
Calliophis bivirgatus

Giant Harlequin Beetle
Acrocinus longimanus

Mimic Poison-Dart Frog
Ranitomeya imitator

Marine Iguana
Amblyrhynchus cristatus

Orange Oakleaf
Kallima inachus

(butterfly)

Palm Cockatoo
Probosciger aterrimus

Pygmy Rattlesnake
Sistrurus miliarius

Yonahlossee Salamander
Plethodon yonahlossee

Eupholus magnificus

(weevil)

Baron's Painted Mantella
Mantella baroni

(frog)

Gray Catbird
Dumetella carolinensis

Dwarf Yellow-Headed Gecko
Lygodactylus luteopicturatus

Harlequin Pink-Belly Frog
Atelopus flavescens

Corinna Daggerwing
Marpesia corinna

(butterfly)

Timber Rattlesnake
Crotalus horridus

Western Collared Lizard
Crotaphytus collaris

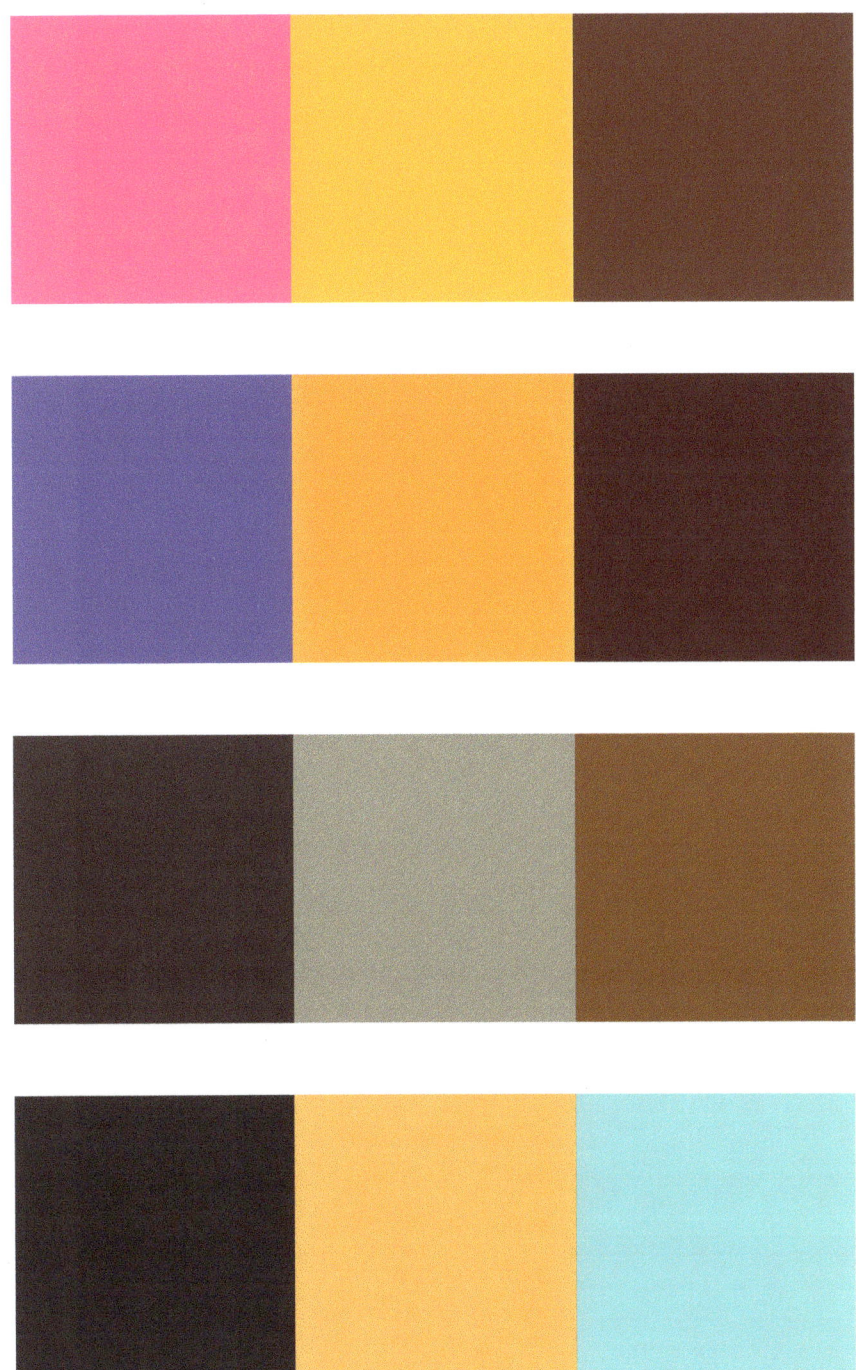

Banded Cucumber Beetle
Diabrotica balteata

Clown Tree Frog
Dendropsophus leucophyllatus

Gumprecht's Green Pit Viper
Trimeresurus gumprechti

Taylor's Checkerspot
Euphydryas editha taylori

(butterfly)

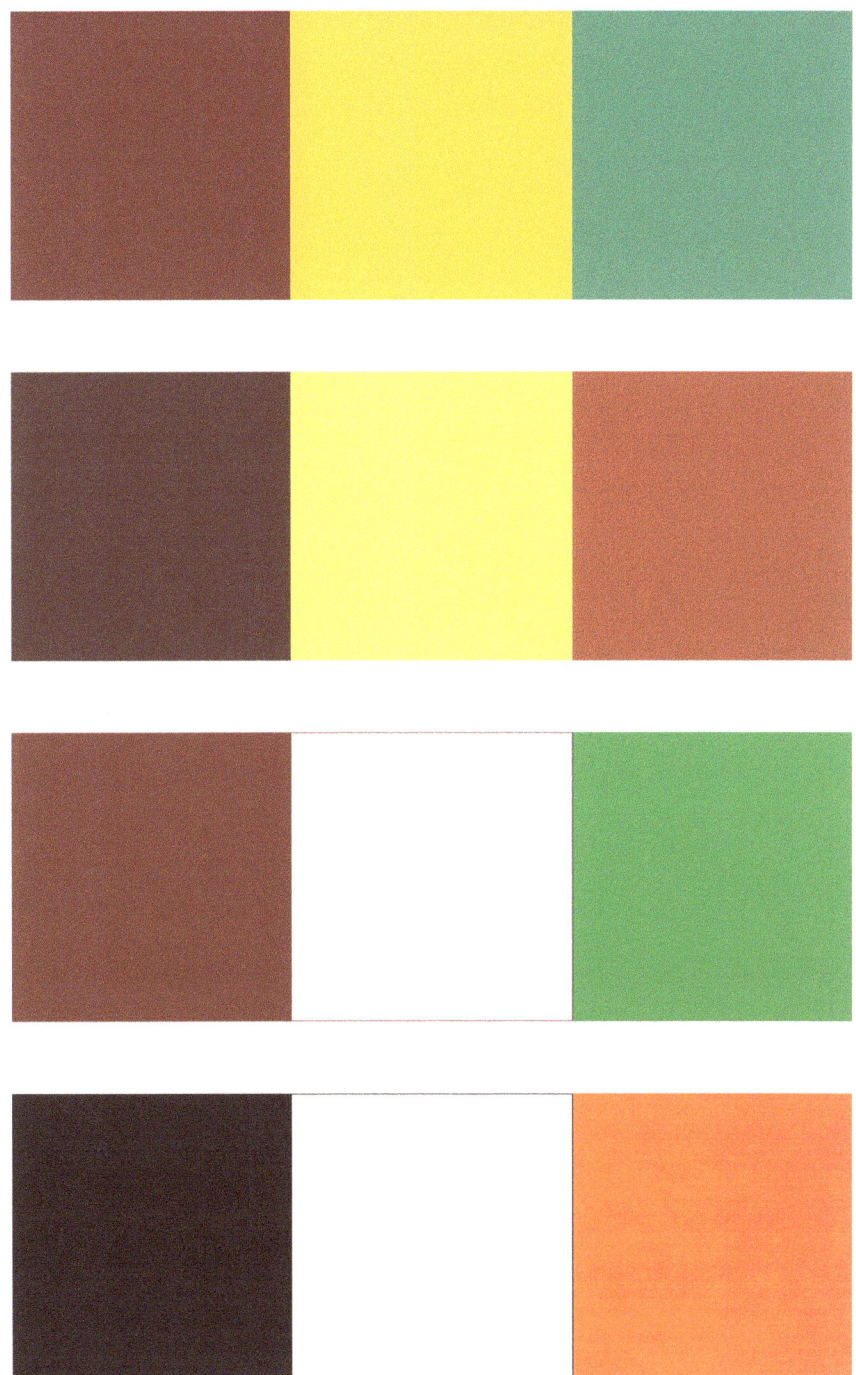

Blue-Tailed Day Gecko
Phelsuma cepediana

Sternotomis pulchra

(longhorned beetle)

Kahuna Nudibranch
Thorunna kahuna

Royal Walnut Moth
Citheronia regalis

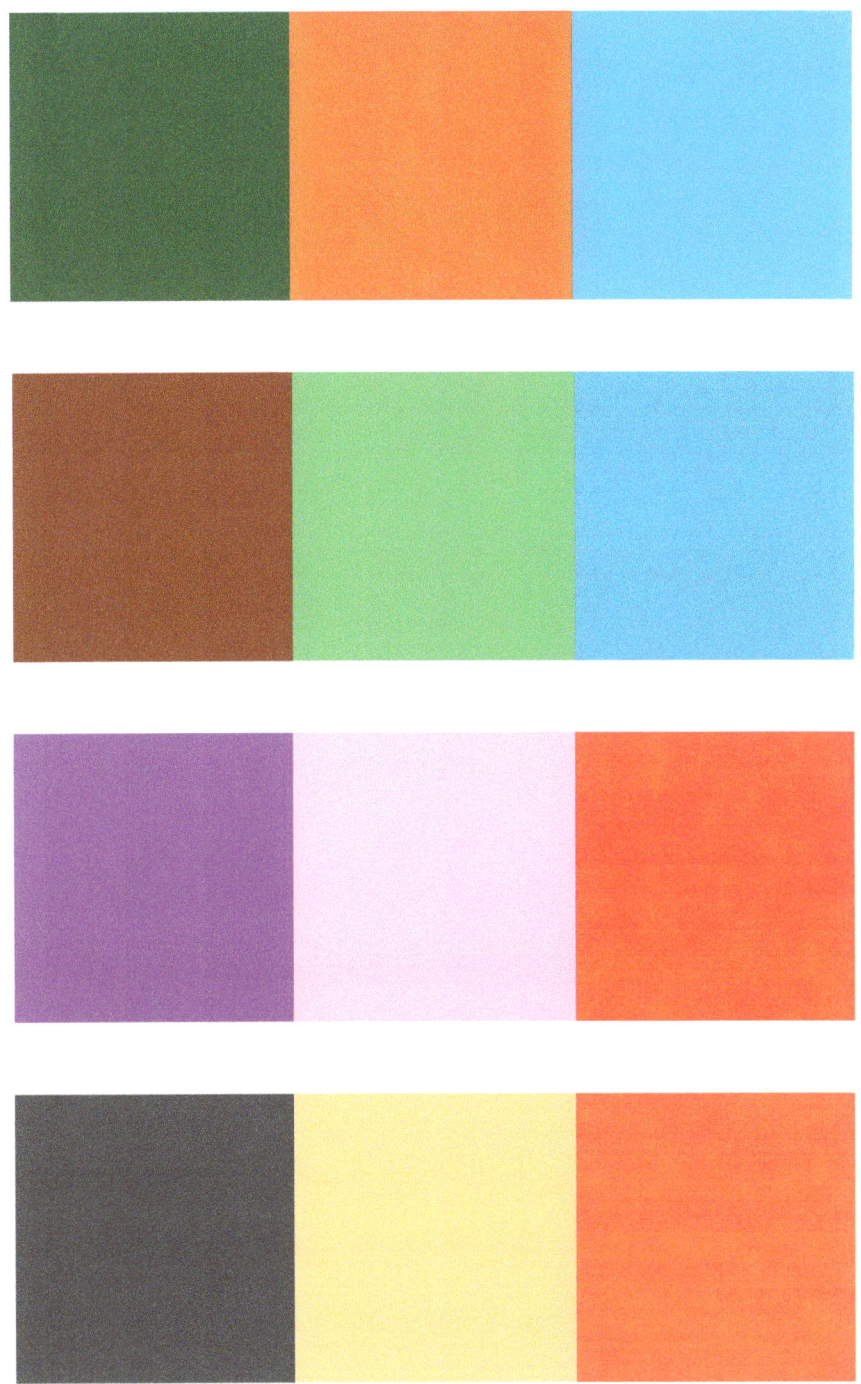

Central Bright-Eyed Frog
Boophis rappiodes

Green Tree Python
Morelia viridis

Phantasmal Poison-Dart Frog
Epipedobates tricolor

Celestial Pearl Danio
Danio margaritatus

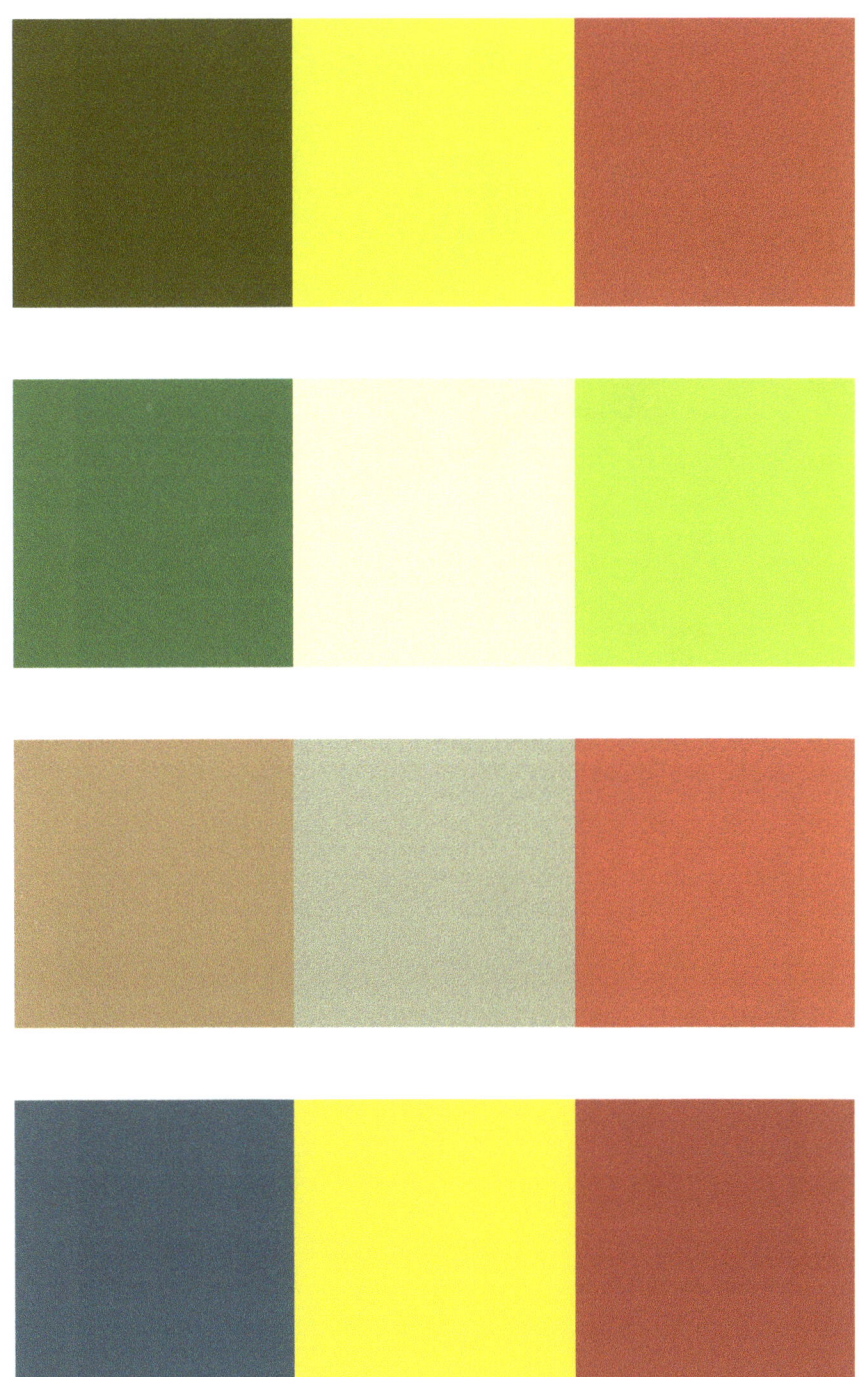

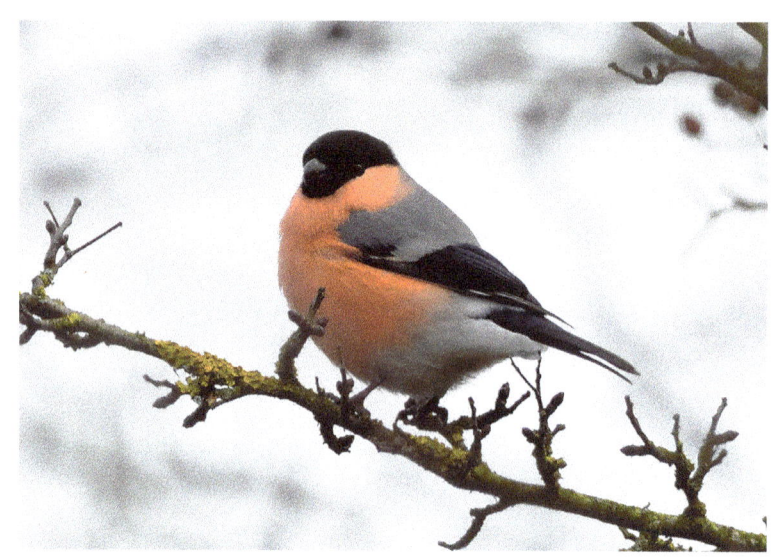

Bullfinch
Pyrrhula pyrrhula

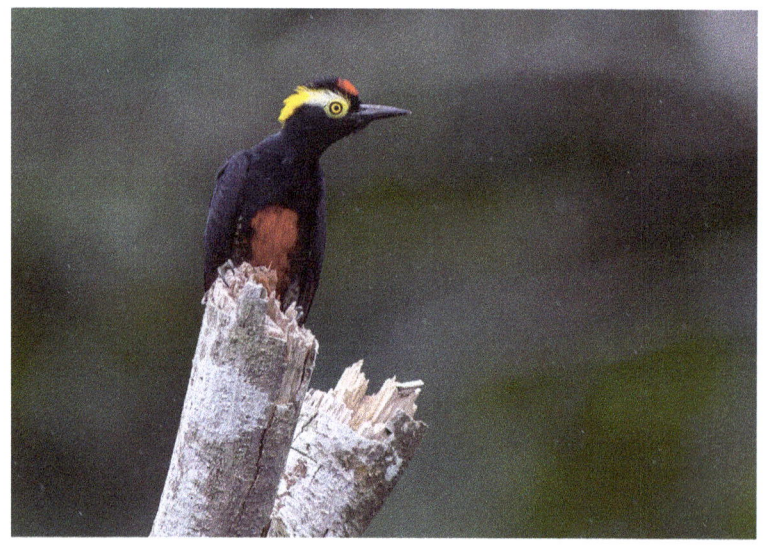

Yellow-Tufted Woodpecker
Melanerpes cruentatus

Four Colors

Cherry-Throated Tanager
Nemosia rourei

Io Moth
Automeris io

Scarlet Tiger Moth
Callimorpha dominula

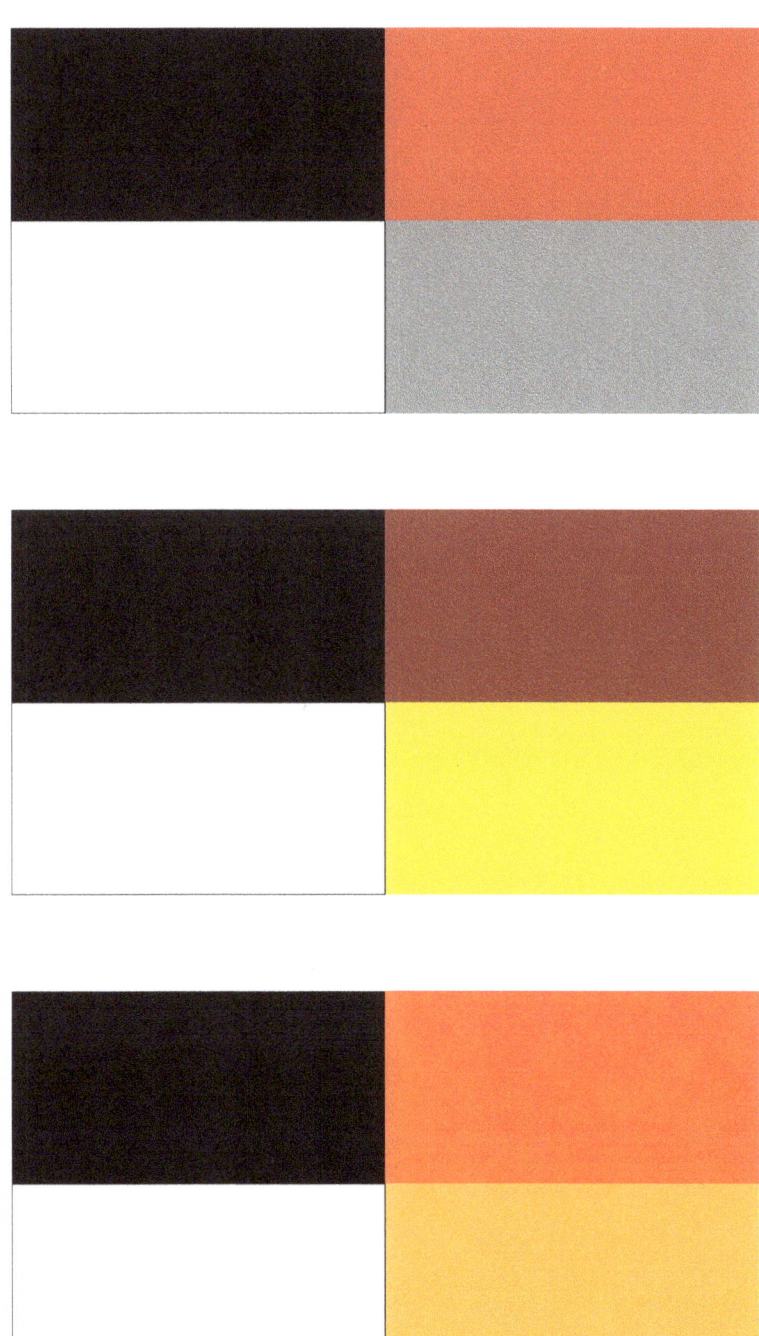

Resplendent Quetzal
Pharomachrus mocinno

Malagasy Rainbow Frog
Scaphiophryne gottlebei

Lazuli Bunting
Passerina amoena

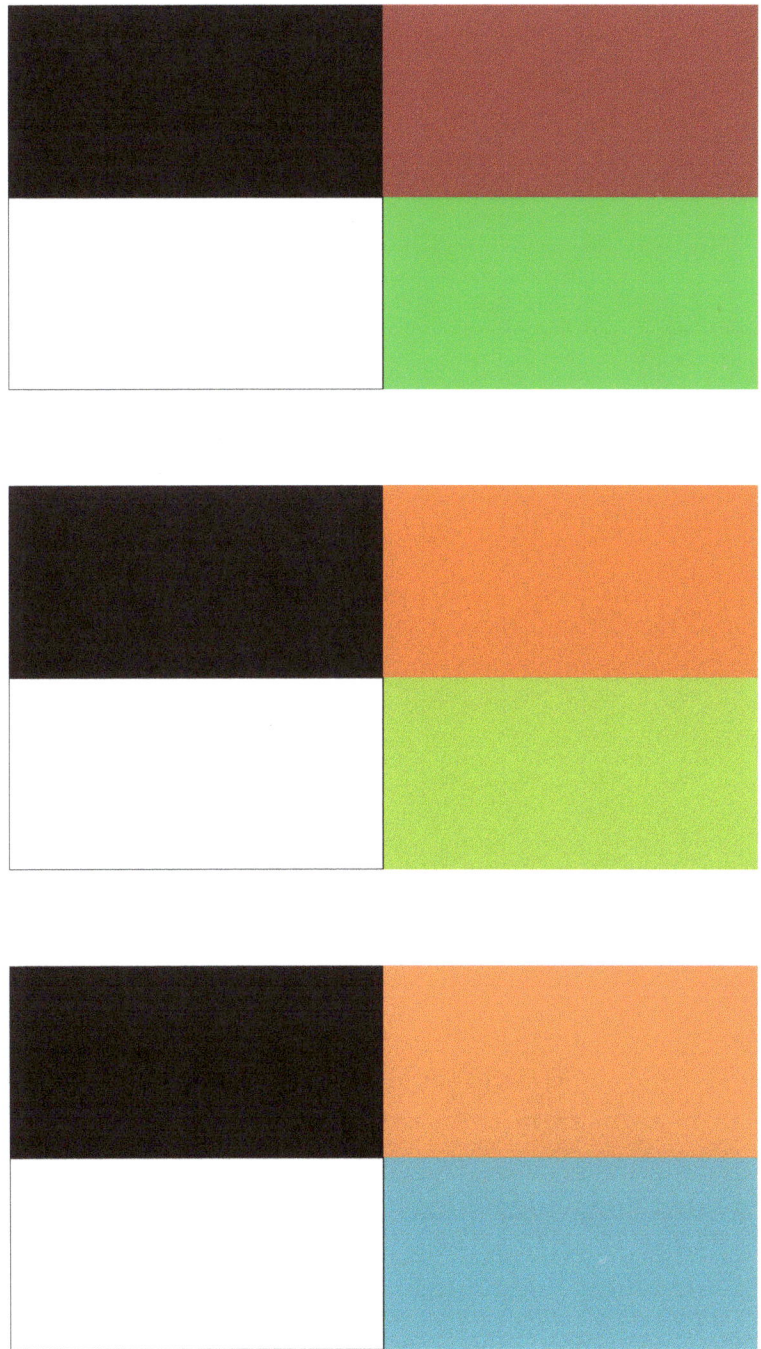

Rufous-Tailed Jacamar
Galbula ruficauda

(bird)

Ladybird Spider
Eresus sandaliatus

African Fat-Tailed Gecko
Hemitheconyx caudicinctus

Garden Tiger Moth
Arctia caja

Cecropia Moth
Hyalophora cecropia

Galah
Eolophus roseicapilla

(bird)

Dermestid Beetle
Anthrenus sp.

Dark-Eyed Junco
Junco hyemalis

Snow Bunting
Plectrophenax nivalis

Calliope Hummingbird
Selasphorus calliope

Ornate Horned Frog
Ceratophrys ornata

Madagascan Lined Frog
Heterixalus rutenbergi

African Paradise Flycatcher
Terpsiphone viridis

Blue-Faced Honeyeater
Entomyzon cyanotis

Powder Blue Tang
Acanthurus leucosternon

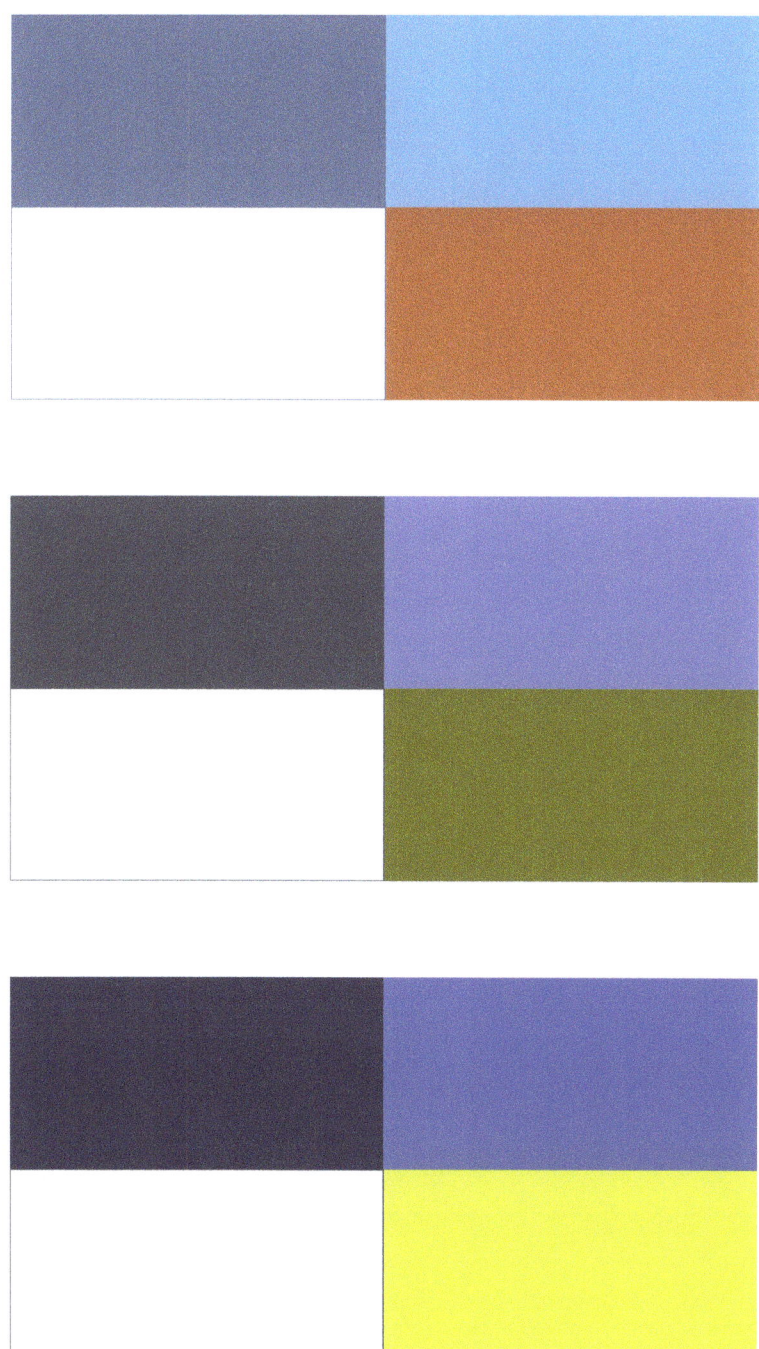

Lantern Bug
Pyrops candelaria

Panther Chameleon
Furcifer pardalis

(One of several possible colorful forms)

Ruby-Throated Hummingbird
Archilochus colubris

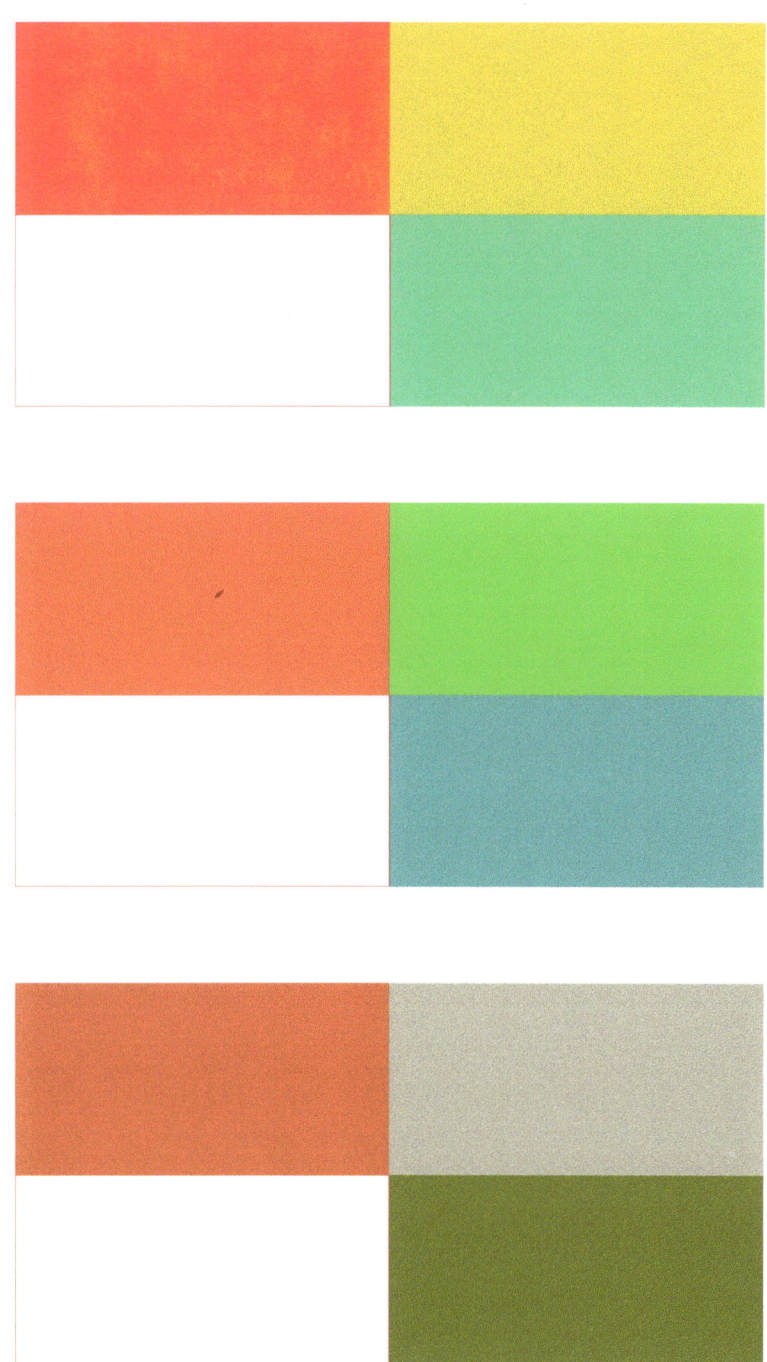

Snowcap
Microchera albocoronata

(hummingbird)

Boesemani Rainbowfish
Melanotaenia boesemani

Golden-Spotted Tiger Beetle
Cicindela aurulenta

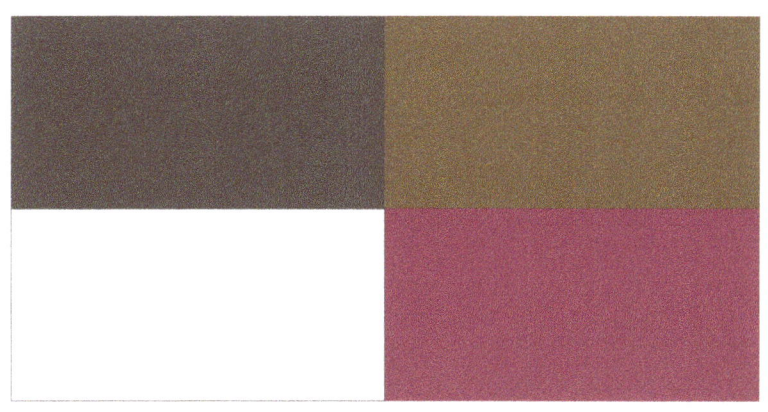
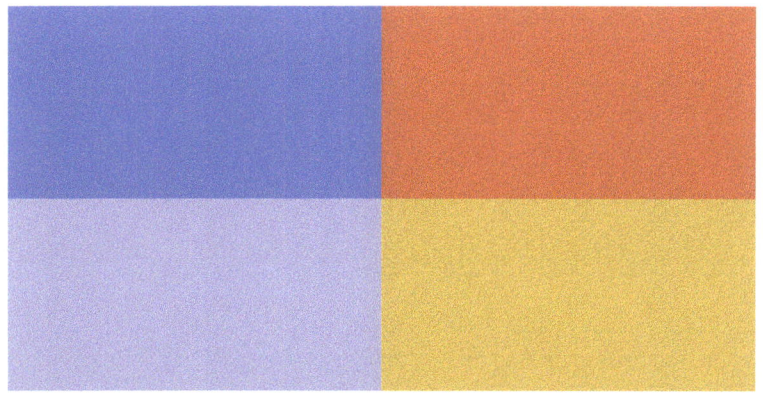

Eastern Tiger Swallowtail
Papilio glaucus

Eclectus Parrot
Eclectus roratus

Blue-Back Reed Frog
Heterixalus madagascariensis

Picasso Bug
Sphaerocoris annulus

Queen Alexandra's Birdwing
Ornithoptera alexandrae

(butterfly)

Red-Banded Treehopper
Graphocephala coccinea

Cotton Harlequin Bug
Tectocoris diophthalmus

Iole's Daggerwing
Marpesia iole

(butterfly)

Woodland Kingfisher
Halcyon senegalensis

Fan-Throated Lizard
Sitana sp.

Oak Treehopper
Platycotis vittata

Rainbow Shield Bug
Calidea dregii

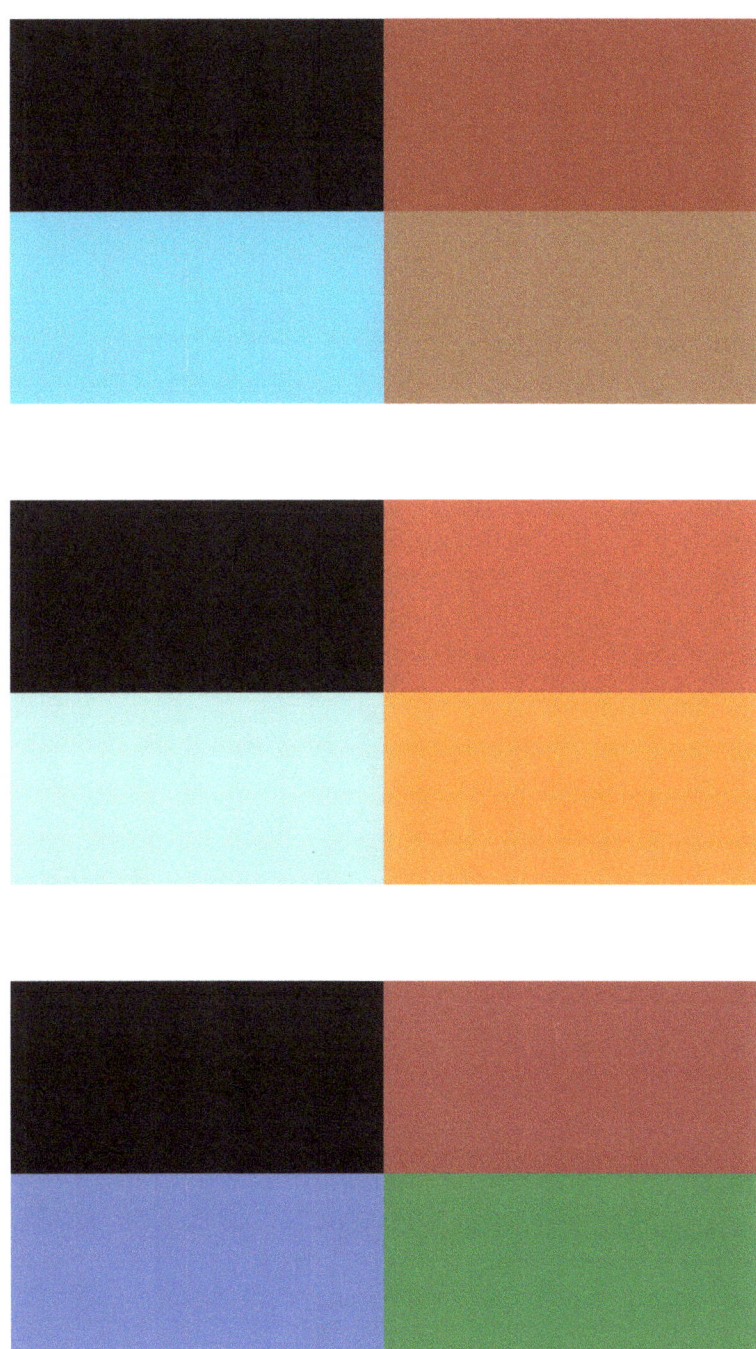

Blood Python
Python curtus

Cape Gopher Snake
Pituophis vertebralis

Marbled Reed Frog
Hyperolius marmoratus

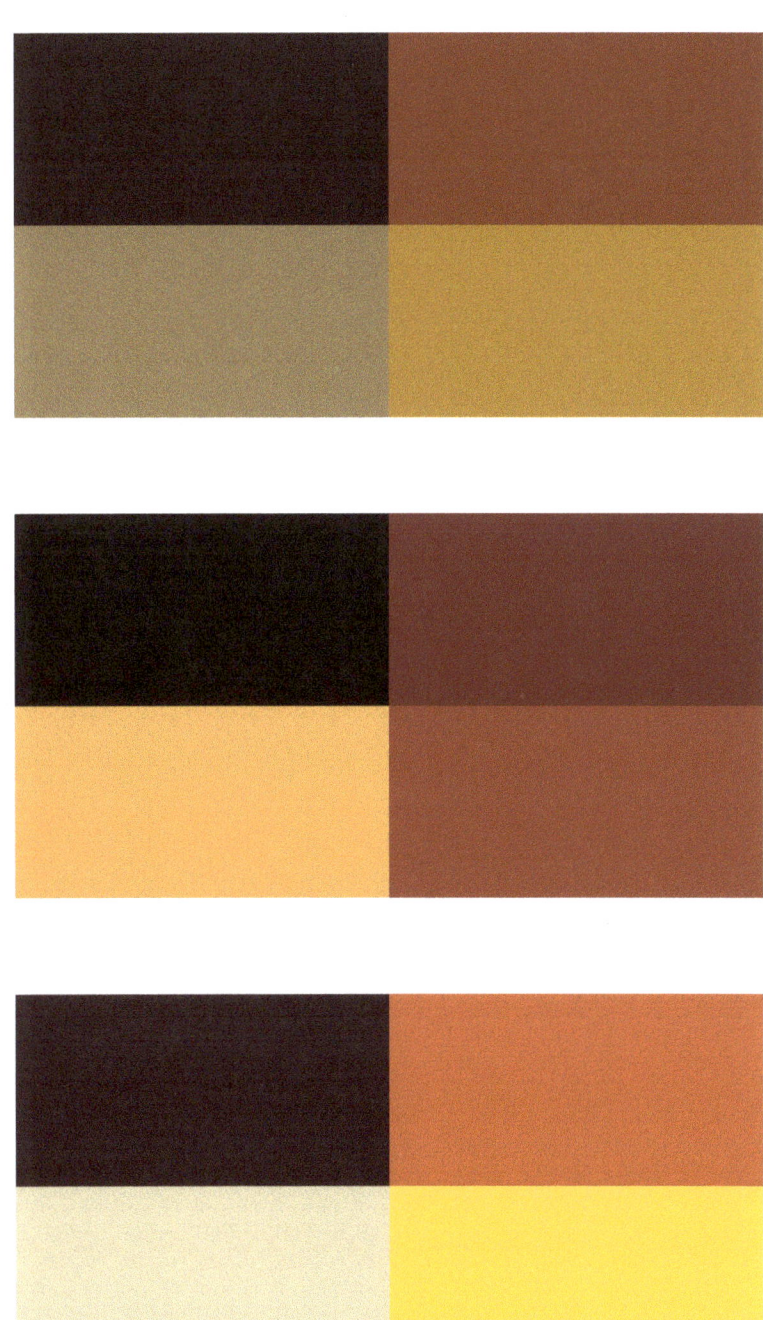

Delta Flower Scarab
Trigonopeltastes delta

Red-Tailed Boa
Boa constrictor

Rhinoceros Viper
Bitis nasicornis

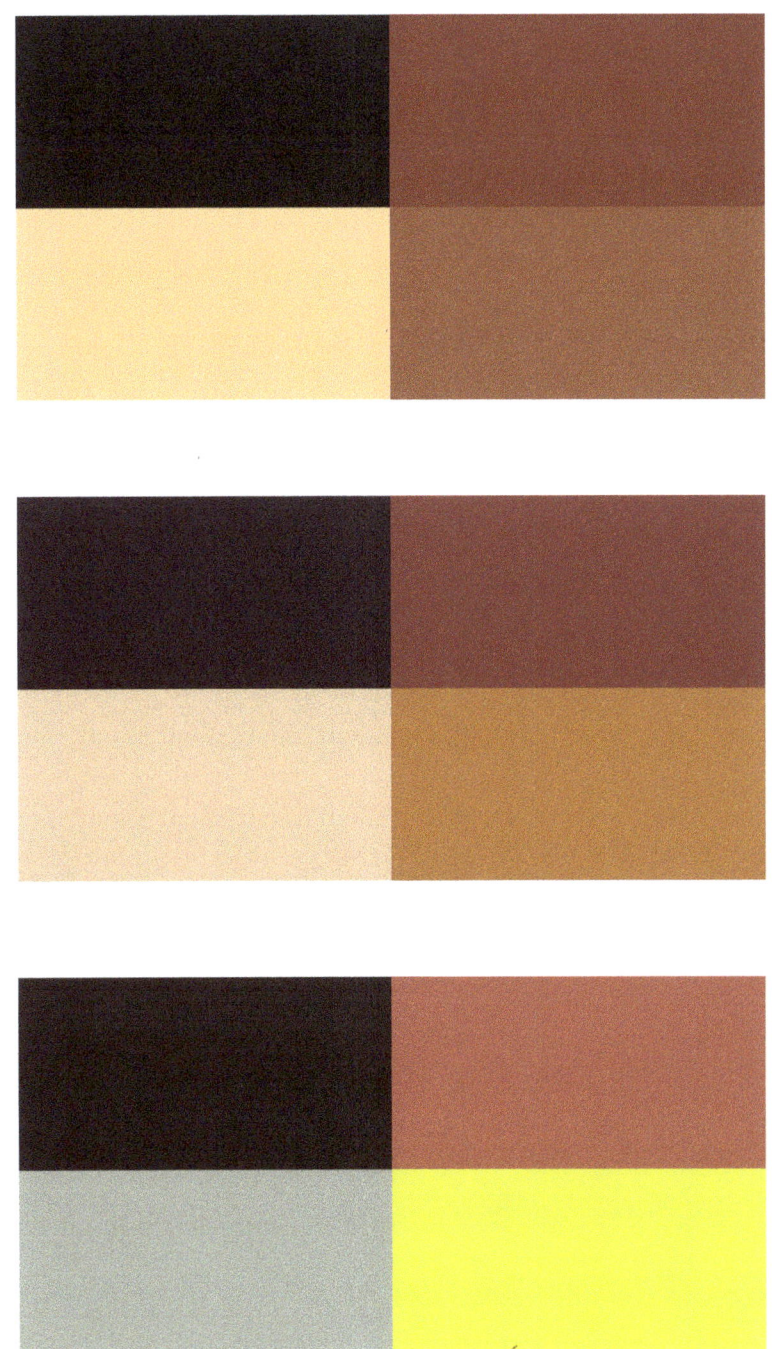

Arachnoscelis feroxnotha

(katydid)

Green-Banded Swallowtail
Papilio nireus

Ornate Flying Snake
Chrysopelea ornata

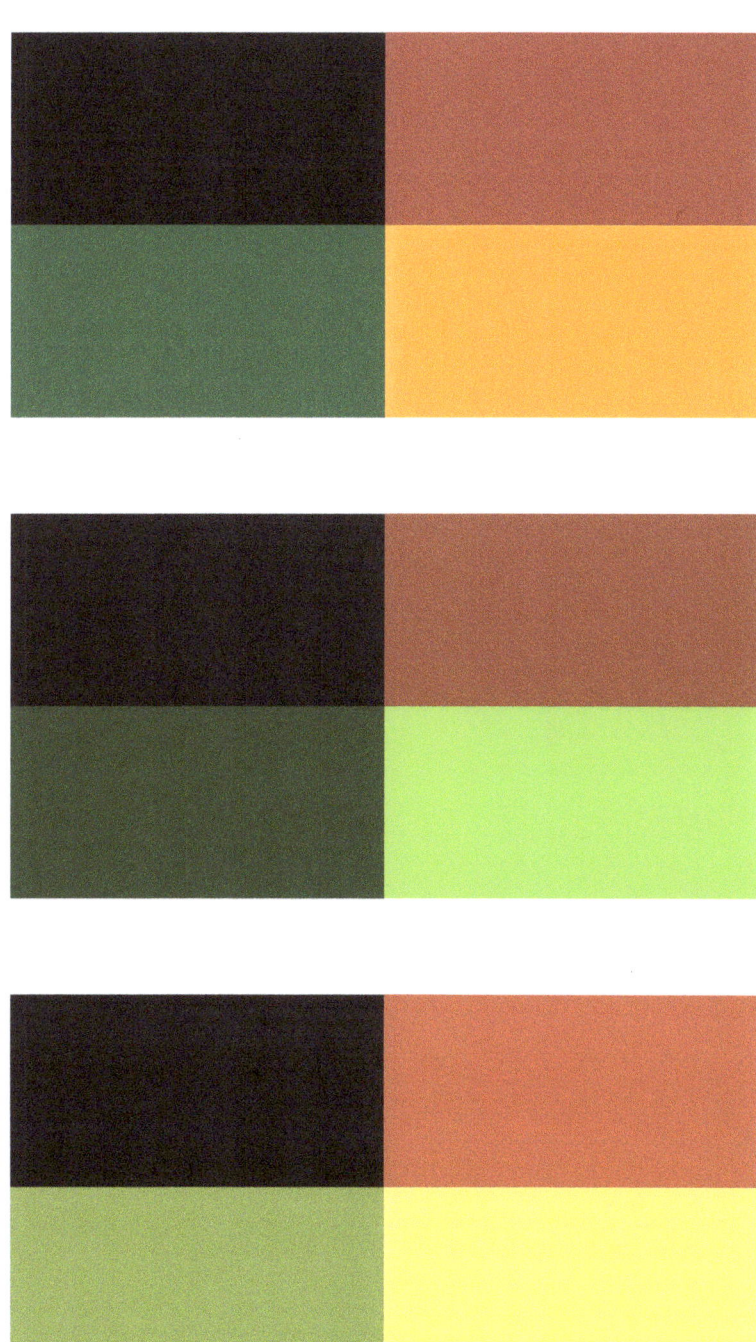

Alpine Newt
Ichthyosaura alpestris

Madagascar *Boophis* sp.

(frog)

Haplochromis sp.

(cichlid fish)

Bay-Headed Tanager
Tangara gyrola

Blue-Tongued Skink
Tiliqua scincoides

Chromodoris magnifica

(nudibranch)

Bullsnake
Pituophis catenifer sayi

Fea's Viper
Azemiops feae

Gaboon Viper
Bitis gabonica

Indian Giant Squirrel
Ratufa indica

Mandarin Ratsnake
Euprepiophis mandarinus

Woma
Aspidites ramsayi

(python)

Black-Necked Garter Snake
Thamnophis cyrtopsis

Campo Flicker
Colaptes campestris

Dalmatian Wall Lizard
Podarcis melisellensis

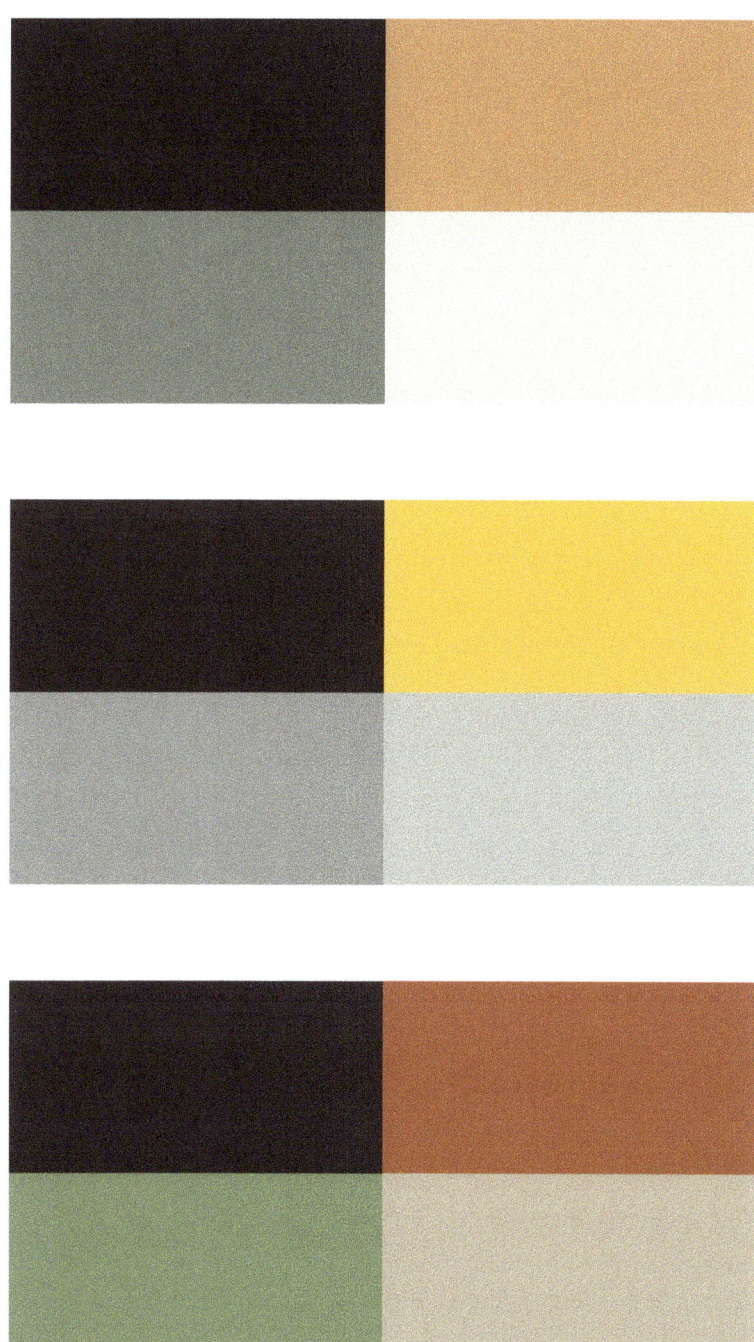

Lychee Shield Bug
Chrysocoris stollii

Pandora Sphinx Moth
Eumorpha pandorus

Rainbow Tree Snake
Gonyosoma margaritatum

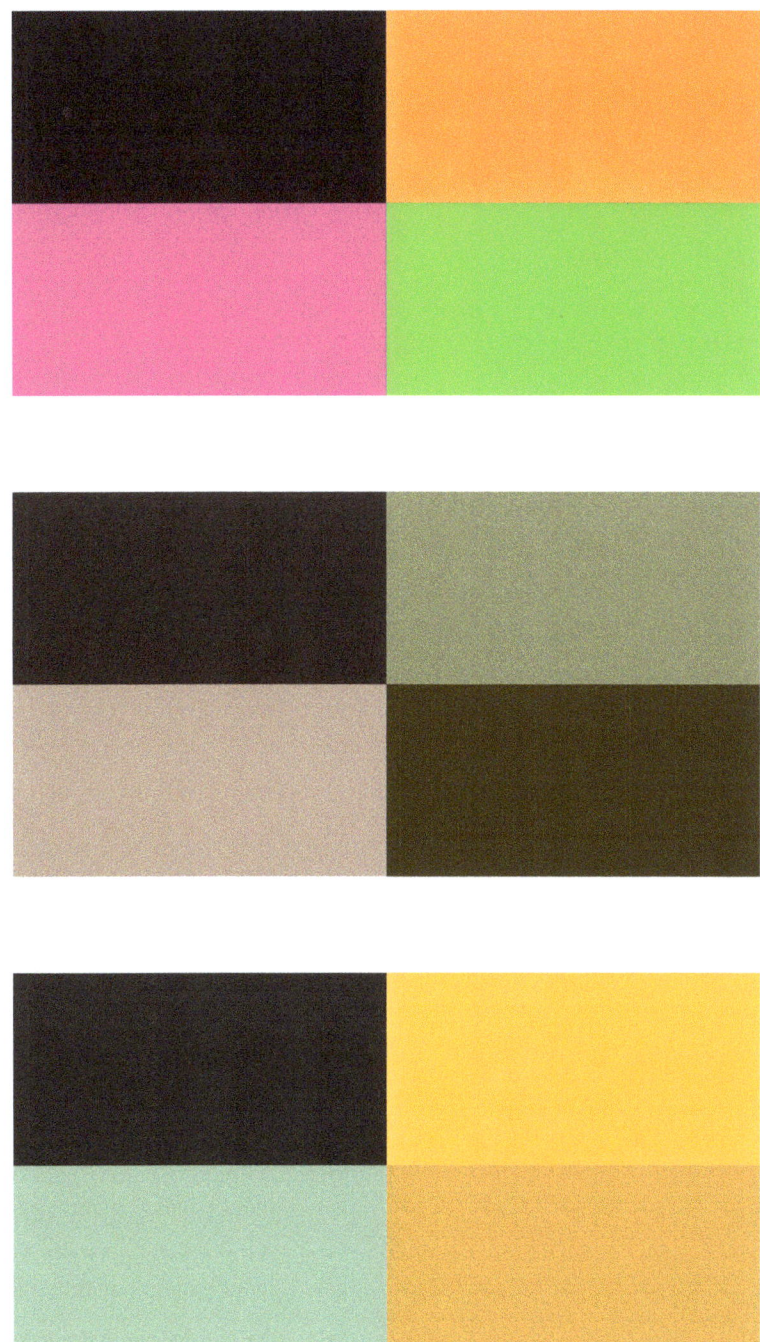

Brazilian Horned Frog
Ceratophrys aurita

Death Adder
Acanthophis antarcticus

Carolina Mountain Dusky Salamander
Desmognathus carolinensis

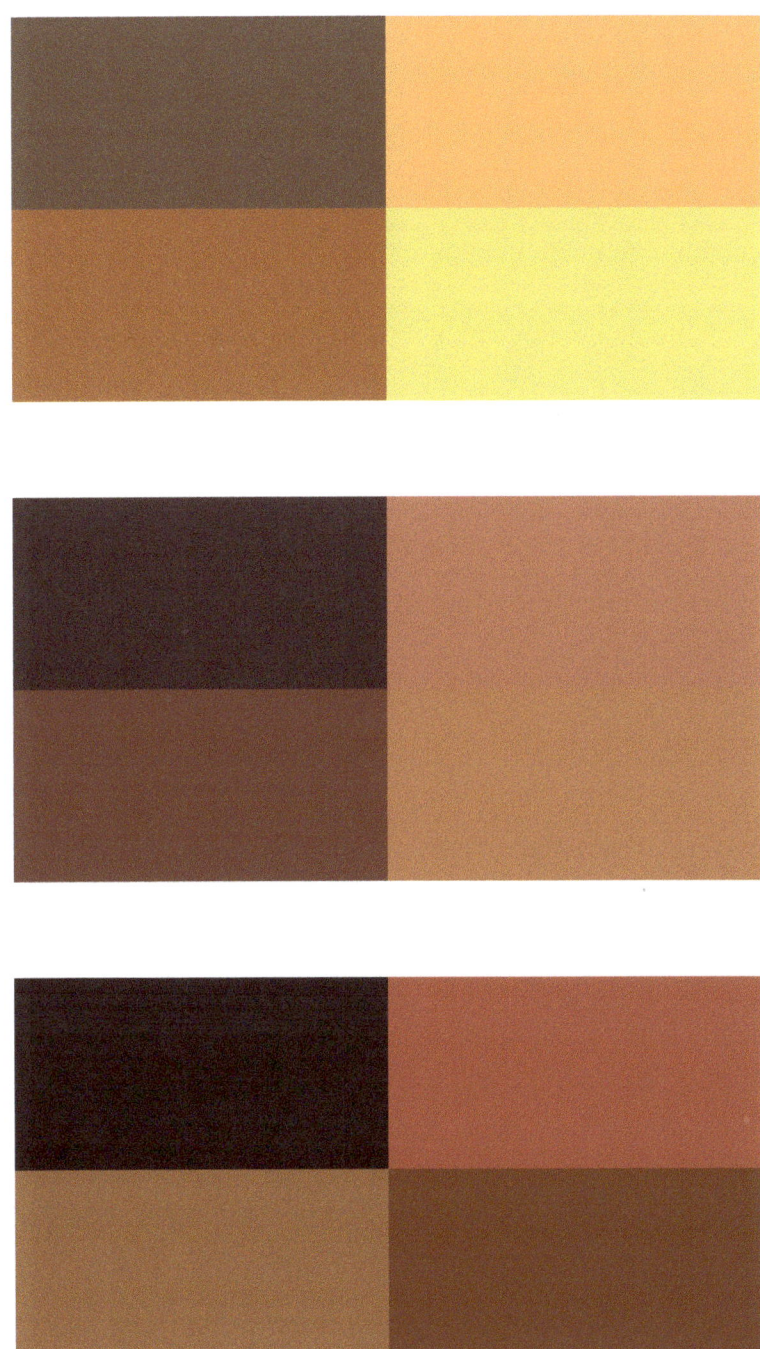

Malaysian Horned Leaf Frog
Megophrys nasuta

Pityeja histrionaria

(Geometer moth)

Red-Legged Running Frog
Kassina maculata

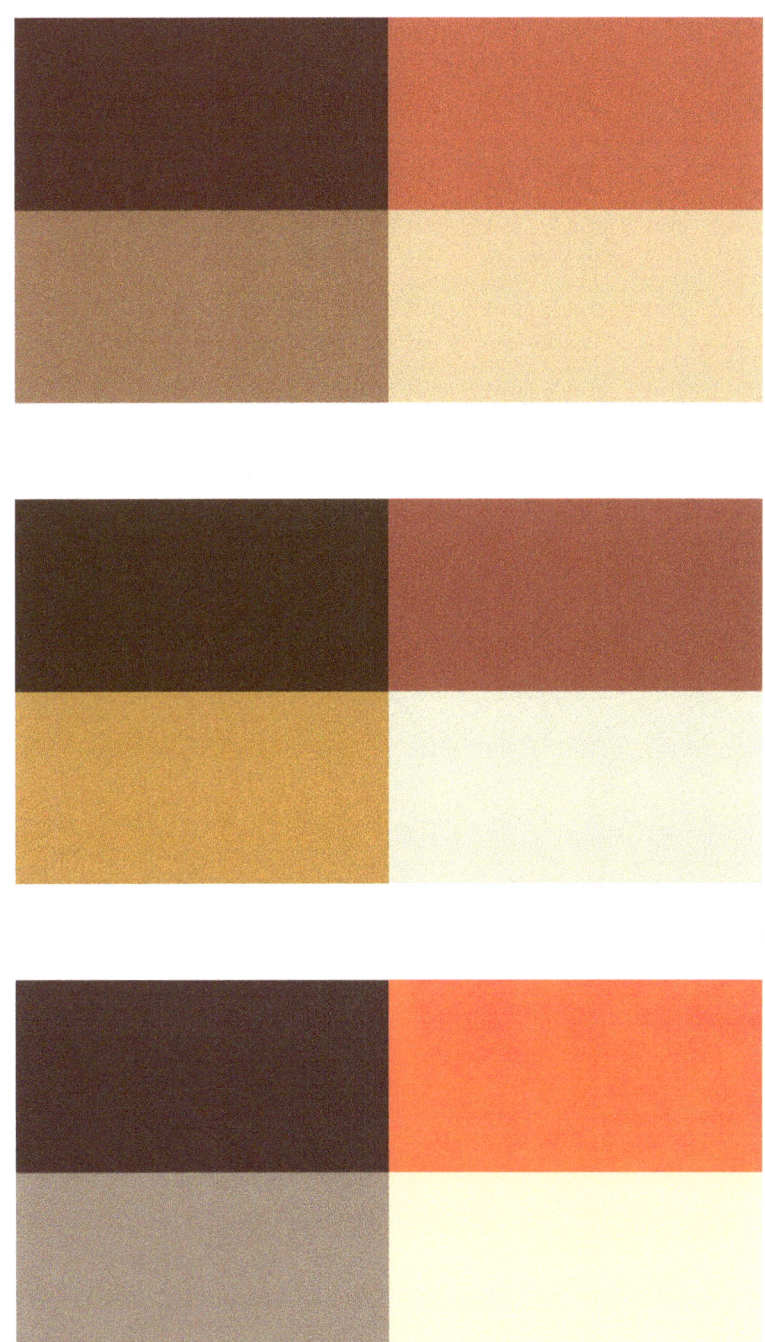

Evergreen Toad
Incilius coniferus

Japanese Beetle
Popillia japonica

European Sand Lizard
Lacerta agilis

Red-Tailed Comet
Sappho sparganurus

(hummingbird)

Senegal Parrot
Poicephalus senegalus

Temognatha alternata

(jewel beetle)

Angolan Painted Reed Frog
Hyperolius sp.

Common Reed Frog
Hyperolius viridiflavus

Red-Eyed Treefrog
Agalychnis callidryas

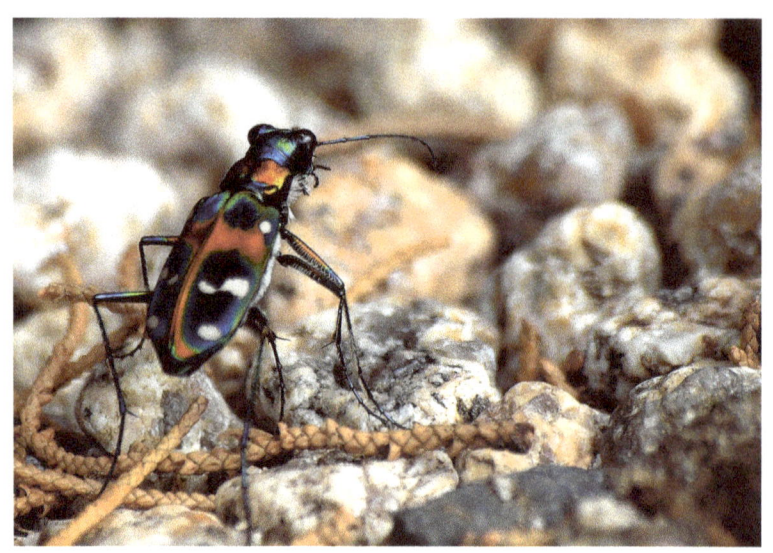

Japanese Tiger Beetle
Cicindela chinensis japonica

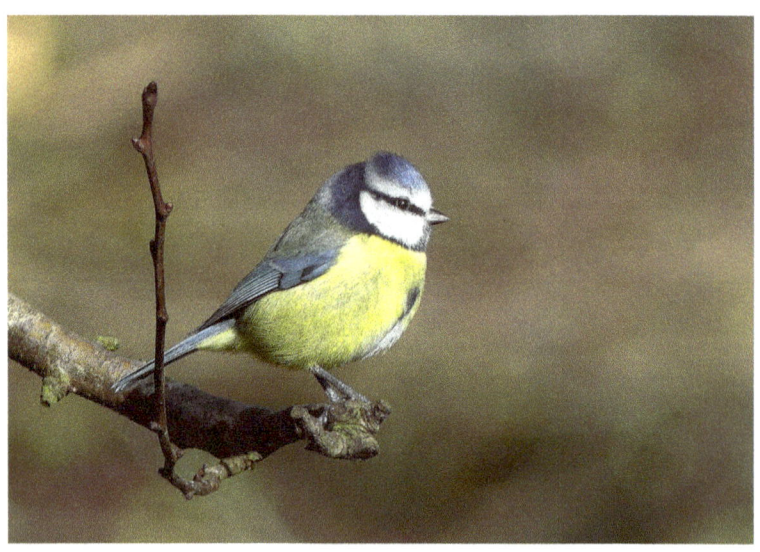

Bluetit
Cyanistes caeruleus

Five Colors

Eurasian Jay
Garrulus glandarius

Northern Mockingbird
Mimus polyglottos

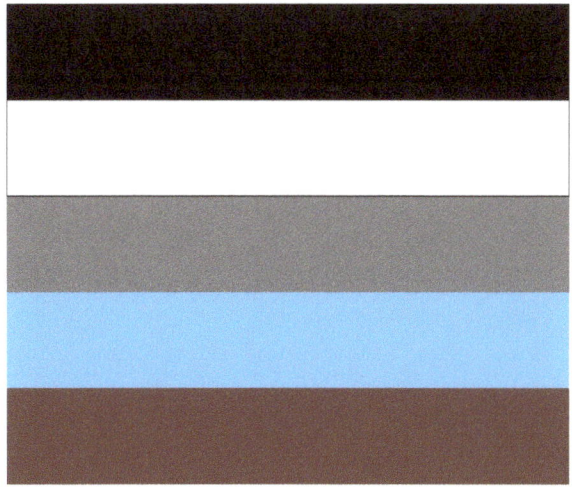

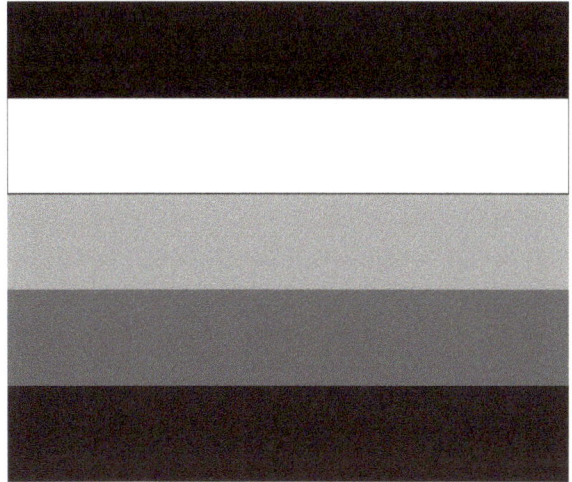

Chromodoris elisabethina

(nudibranch)

Scarlet Macaw
Ara macao

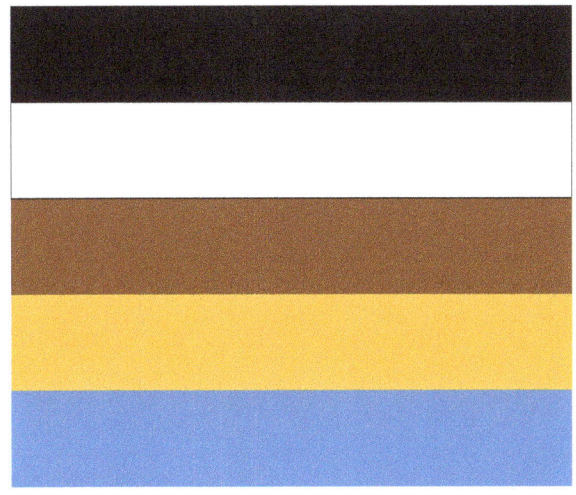

Whiskered Treeswift
Hemiprocne comata

White-Throated Kingfisher
Halcyon smyrnensis

Mandrill
Mandrillus sphinx

Pyjama Slug
Chromodoris quadricolor

(nudibranch)

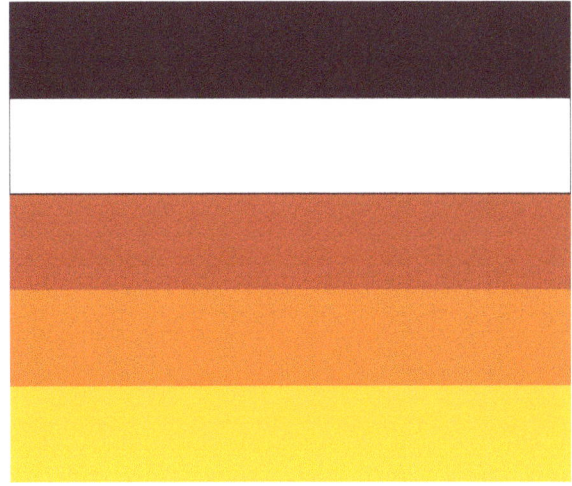

Australian King Parrot
Alisterus scapularis

Nanday Parakeet
Aratinga nenday

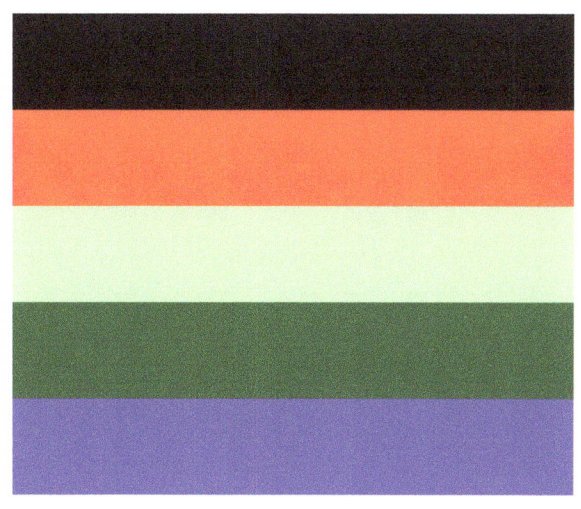

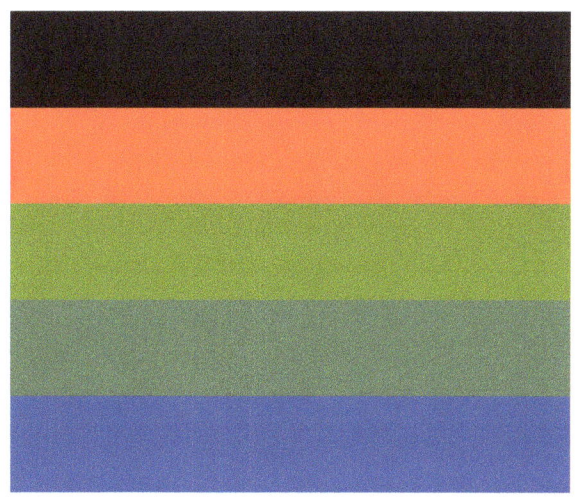

Green Cochoa
Cochoa viridis

(bird)

Little Harlequin Katydid
Paraxiphidium iriodes

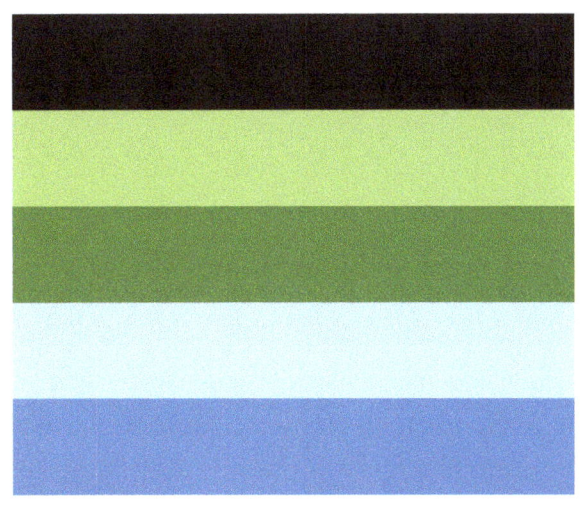

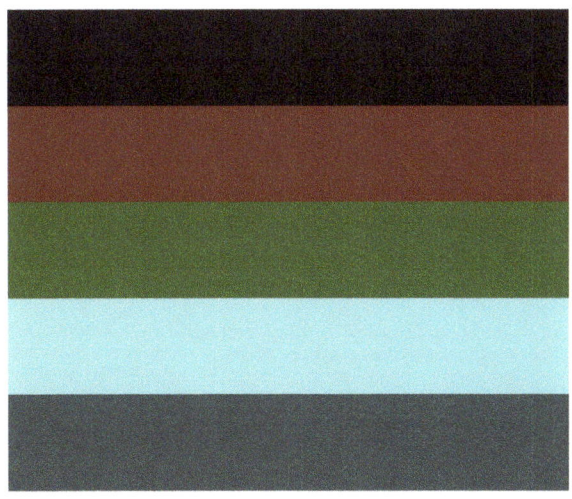

Green-Headed Tanager
Tangara seledon

Northern Green Jumping Spider
Mopsus mormon

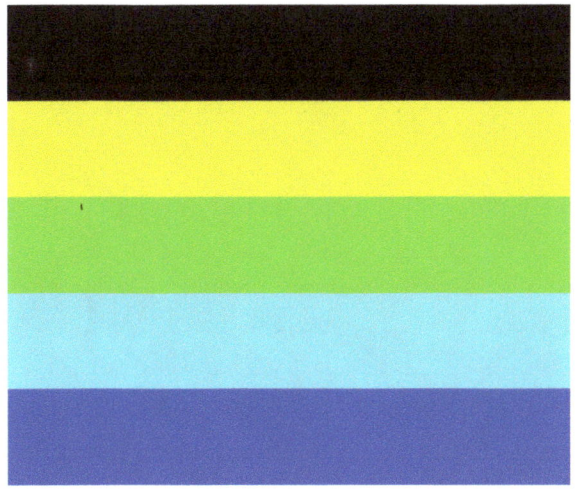

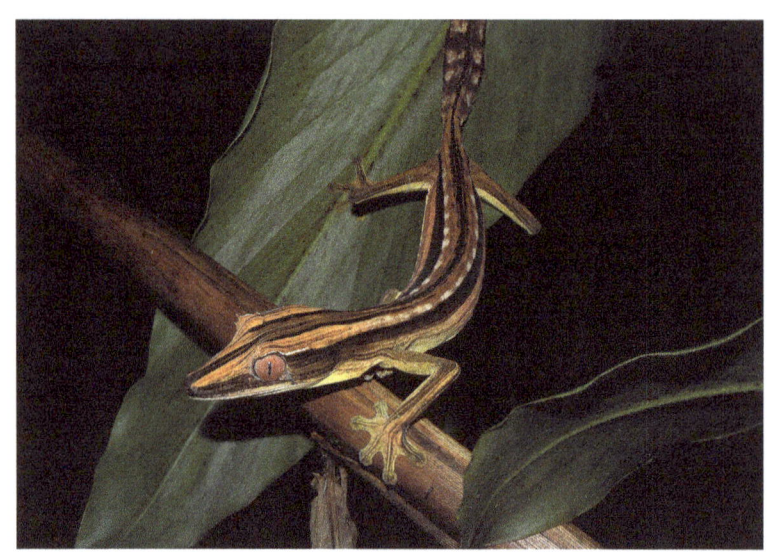

Lined Leaf-Tailed Gecko
Uroplatus lineatus

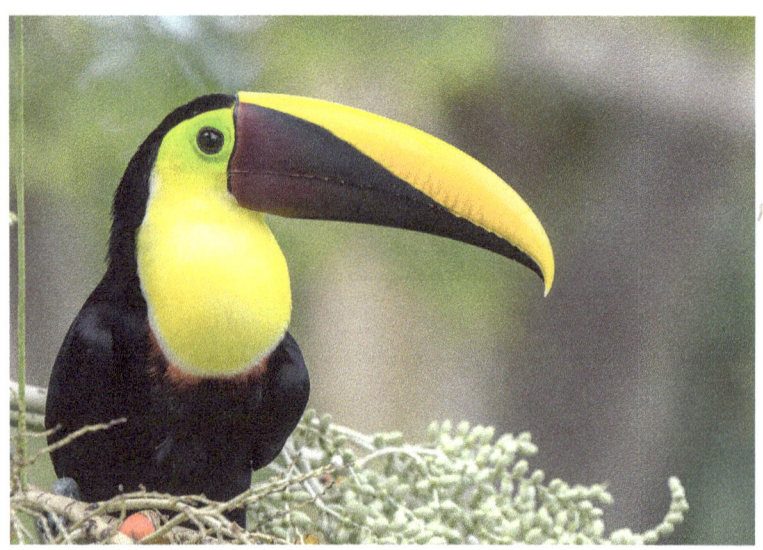

Yellow-Throated Toucan
Ramphastos ambiguus

Six Colors

Bee Hummingbird
Mellisuga helenae

Picasso Triggerfish
Rhinecanthus aculeatus

King Bird-of-Paradise
Cicinnurus regius

Silvery Kingfisher
Alcedo argentata

Crested Partridge
Rollulus rouloul

Golden Pheasant
Chrysolophus pictus

Green Jay
Cyanocorax yncas

Guianan Trogon
Trogon violaceus

Black-Backed Kingfisher
Ceyx erithaca

Lesser Bird-of-Paradise
Paradisaea minor

Chukar
Alectoris chukar

White-Lined Sphinx Moth
Hyles lineata

Blue Pansy
Junonia orithya

(butterfly)

Buckeye
Junonia coenia

(butterfly)

Hawaiian Triggerfish
Rhinecanthus rectangulus

Hooded Pitta
Pitta sordida

(bird)

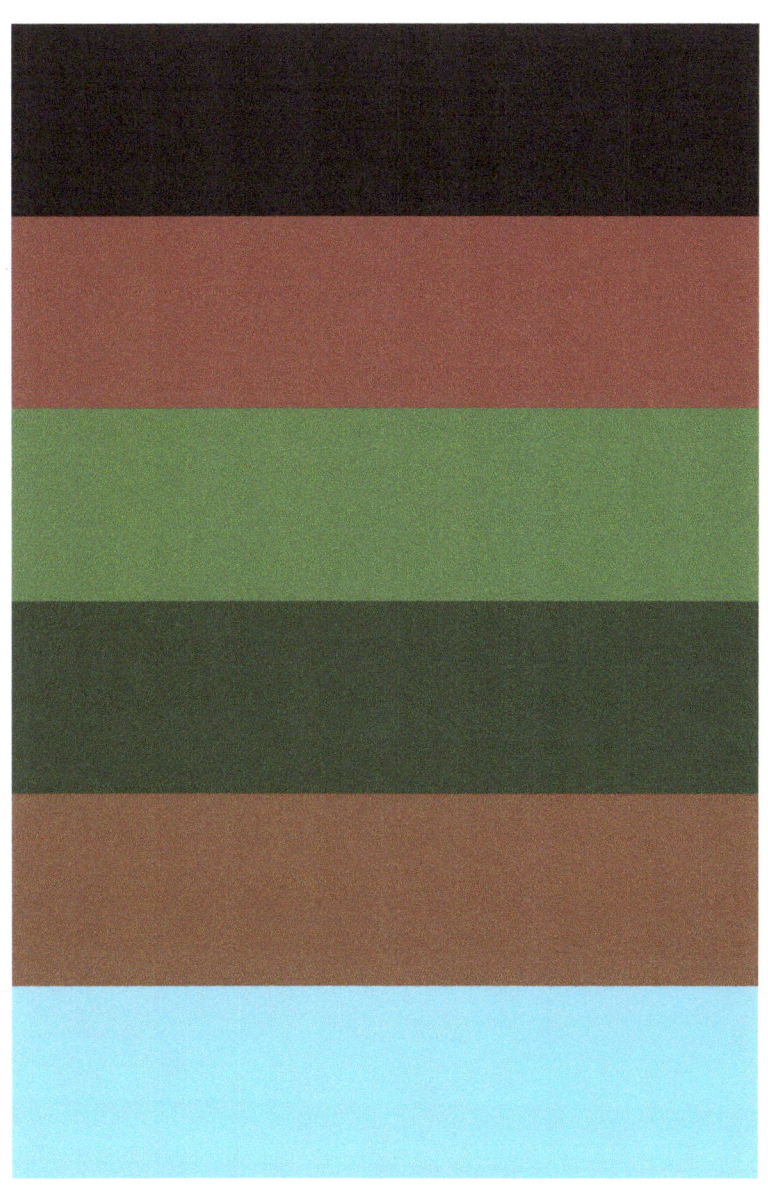

Painted Bunting
Passerina ciris

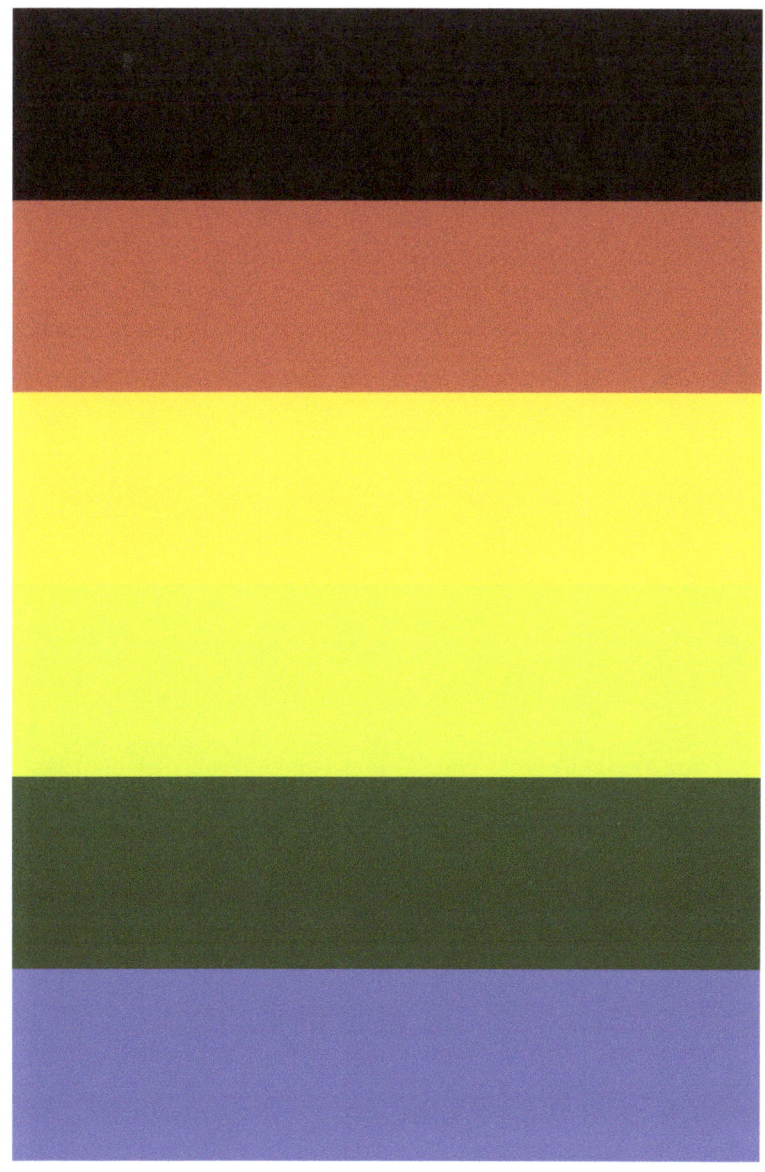

Plum-Headed Parakeet
Psittacula cyanocephala

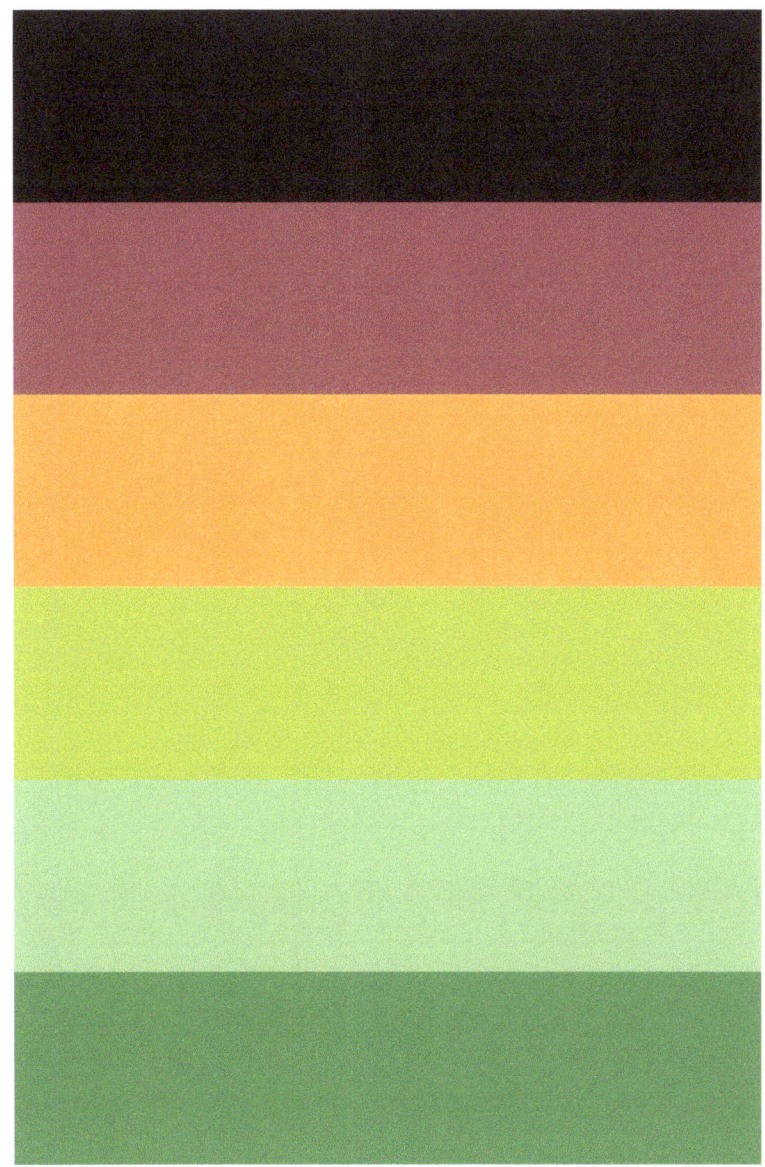

Keel-Billed Toucan
Ramphastos sulfuratus

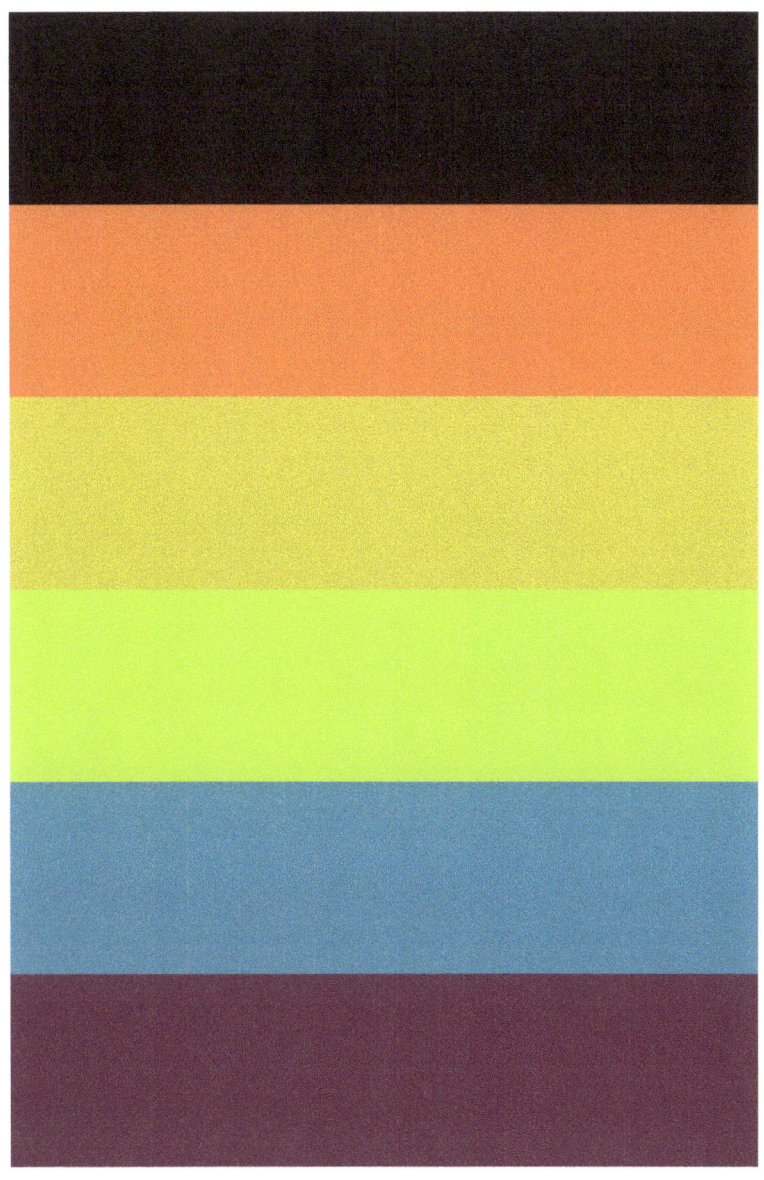

Paradise Tanager
Tangara chilensis

Tufted Coquette
Lophornis ornatus

(hummingbird)

Abel's Katydid
Yestria azureus

Rainbow Lorikeet
Trichoglossus moluccanus

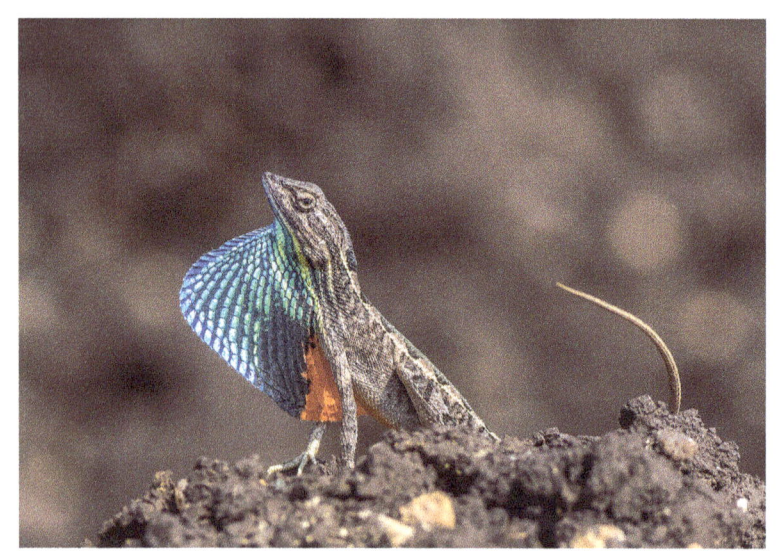

Fan-Throated Lizard
Sitana sp.

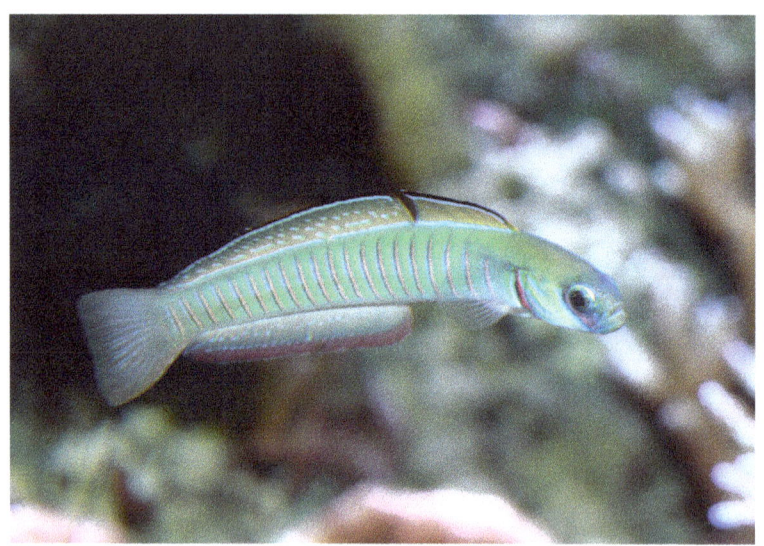

Zebra Banded Dartfish
Ptereleotris zebra

Seven or More Colors

Gouldian Finch
Erythrura gouldiae

Green Magpie
Cissa chinensis

Ring-Necked Pheasant
Phasianus colchicus

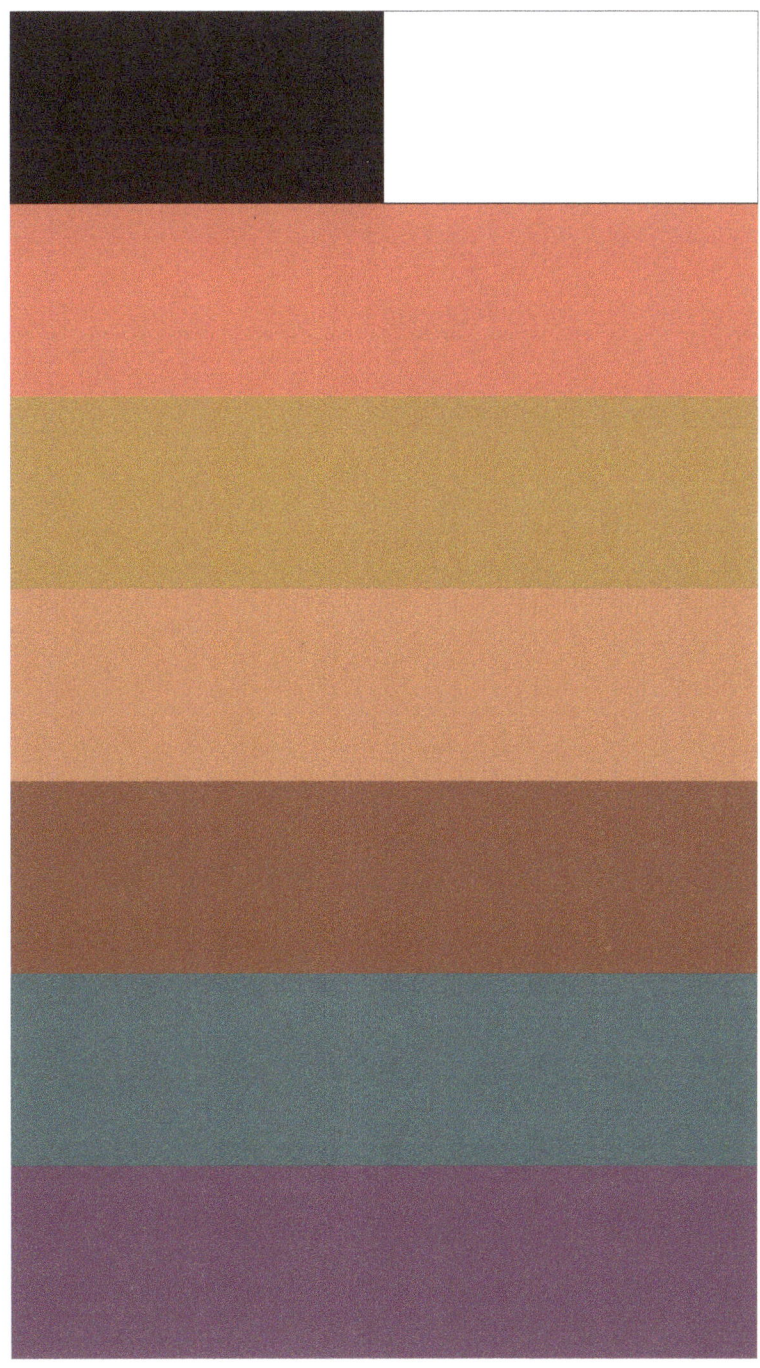

Red-Breasted Parakeet
Psittacula alexandri

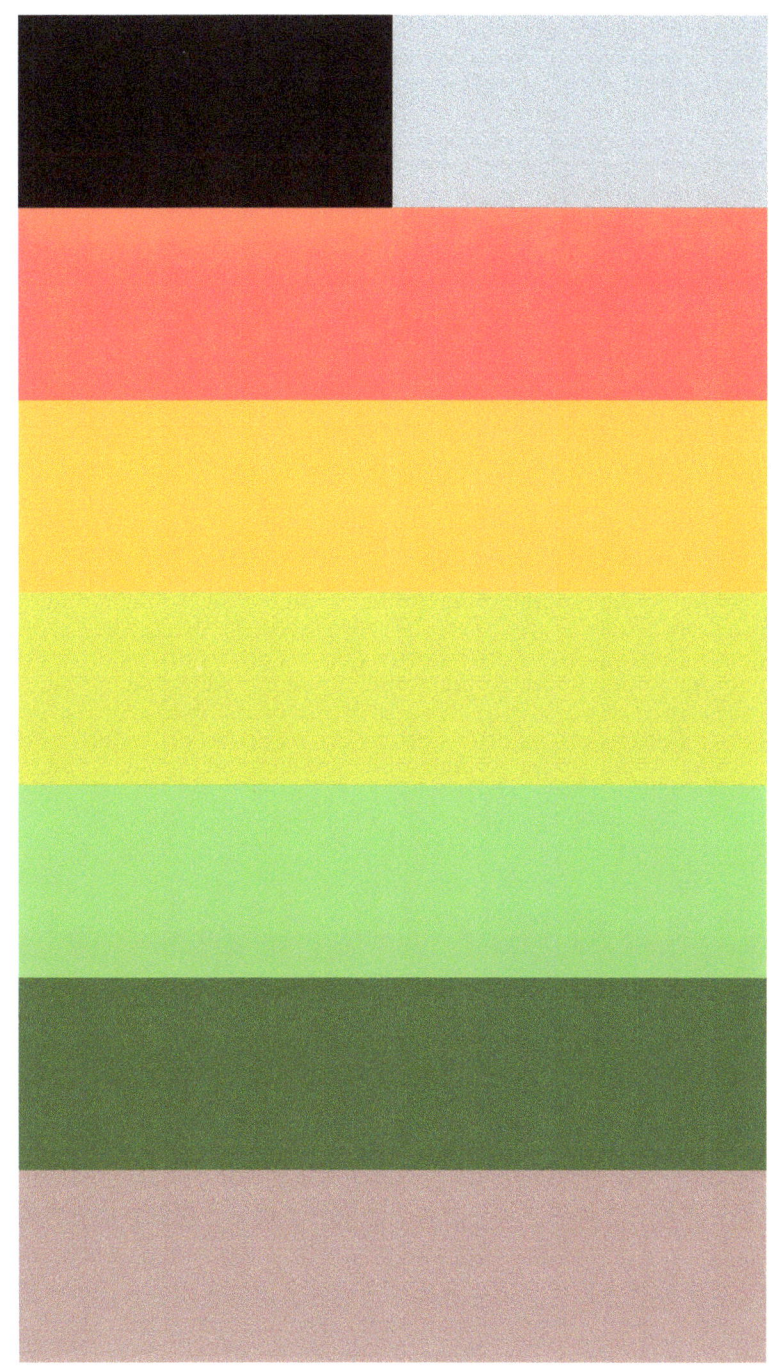

Wilson's Bird-of-Paradise
Cicinnurus respublica

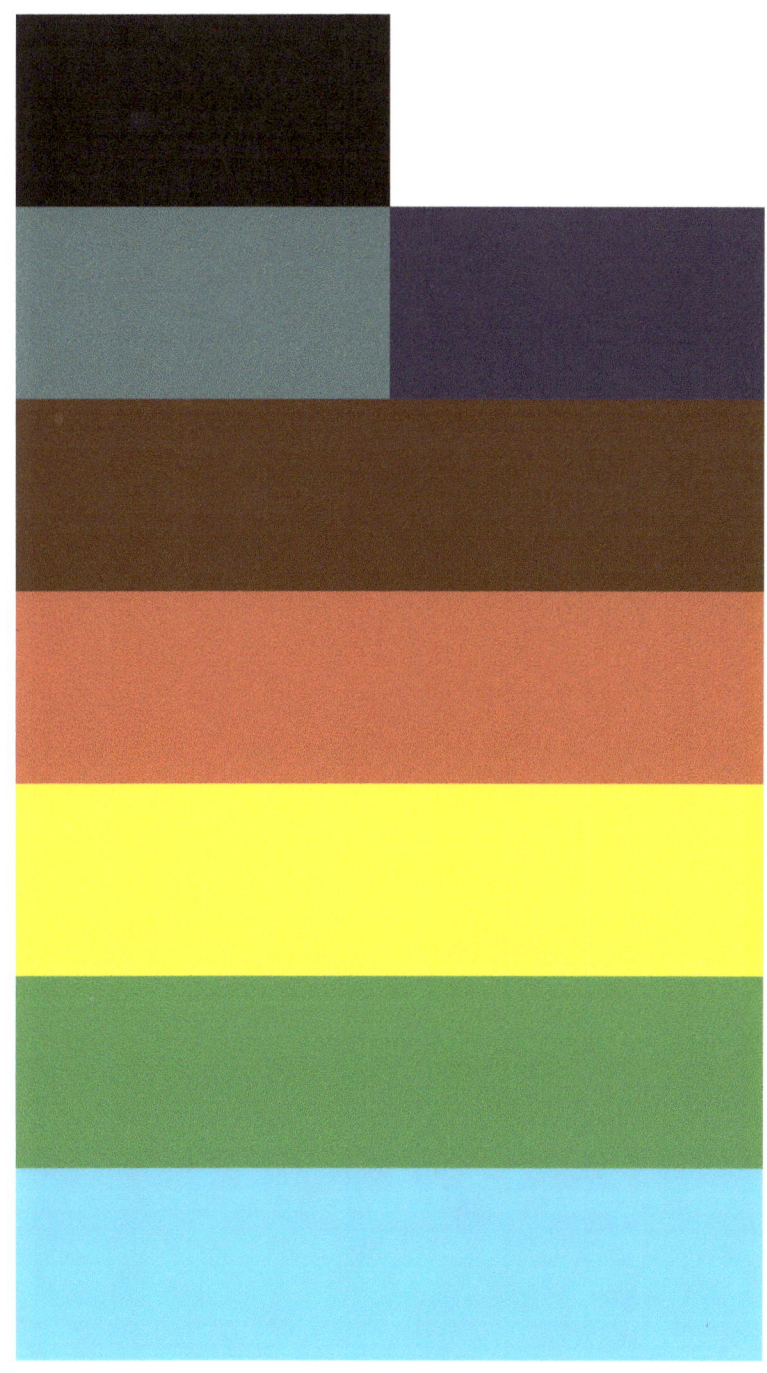

Indian Peafowl
Pavo cristatus

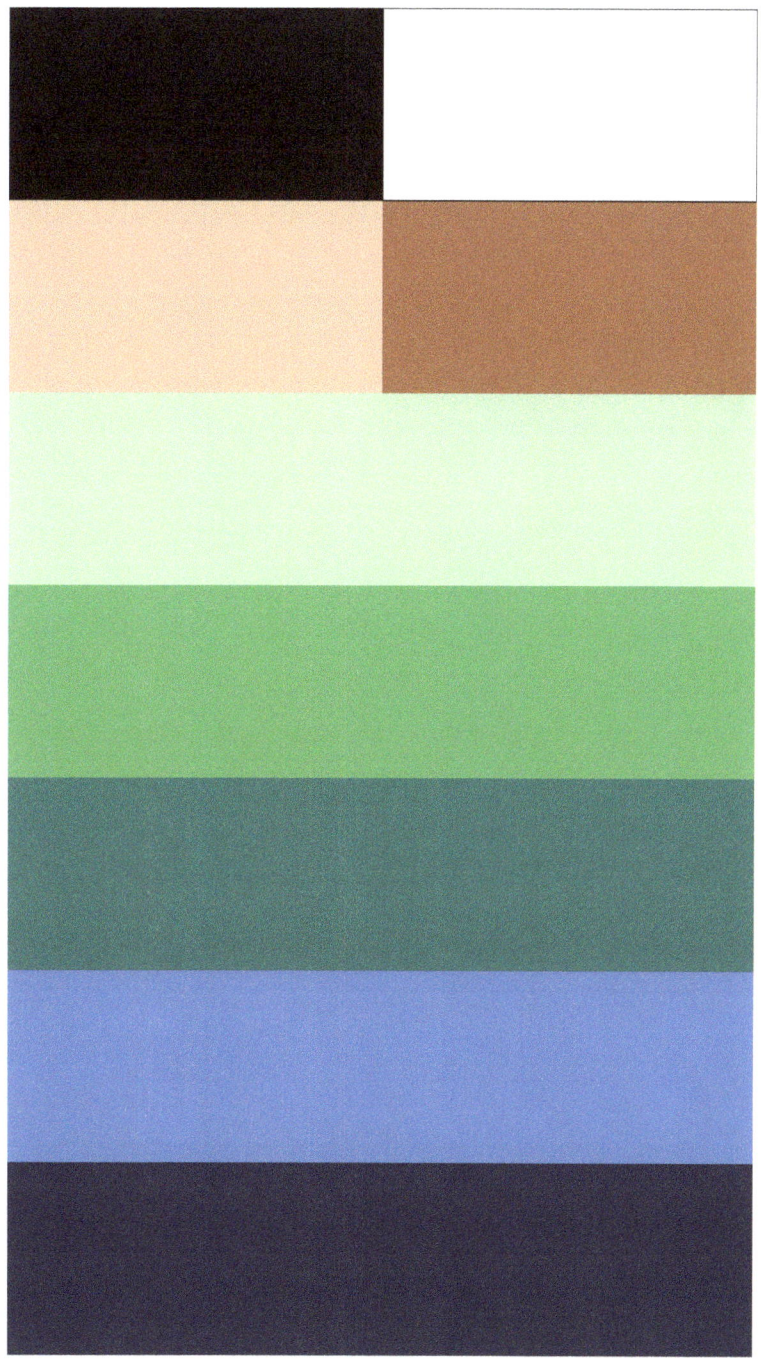

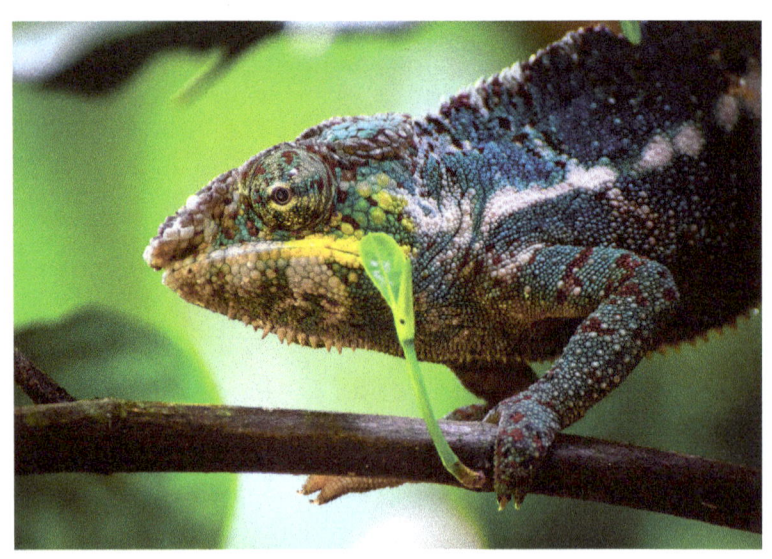

Panther Chameleon
Furcifer pardalis

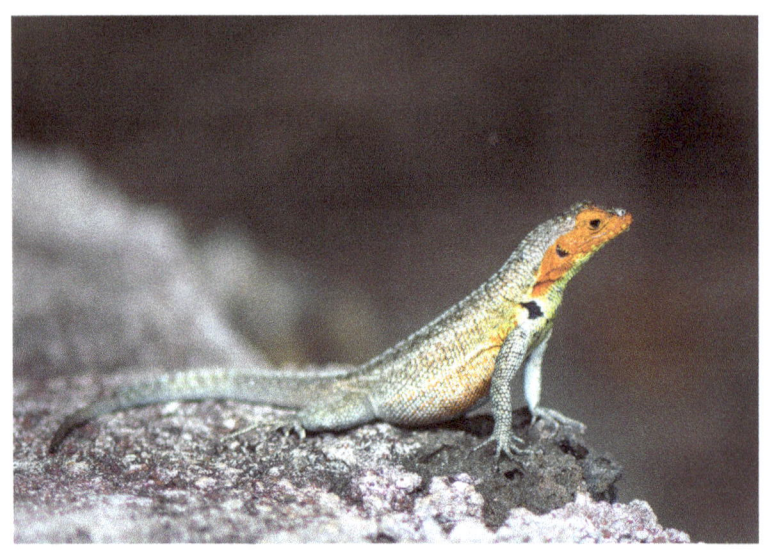

Galápagos Lava Lizard
Microlophus albemarlensis

Photo Credits

Cairns Birdwing (CC-BY) Matthias Liffers
Labord's Chameleon (CC-BY) Frank Vassen
Namib Rock Agama (CC-BY) Simon's Images
Strawberry Poison-Dart Frog (CC-BY) Jay Iwasaki
Sonoran Coral Snake (CC-BY-SA) David Jahn
Scarlet Kingsnake (PD) Tim Johnson
Violet-Crowned Woodnymph (CC-BY) Brian Gratwicke
Iridescent Beetle (CC-BY) Yogendra Joshi
Siphonophores by IFE, URI-IAO, UW, Lost City Science Party; NOAA/OAR/OER; The Lost City 2005 Expedition
Glasswing Butterfly (CC-BY) William Warby
Razorbill © Jerome Whittingham
Great White Shark (CC-BY) Elias Levy
Snowy Owl (CC-BY) Silver Leapers
Eastern Common Firefly (CC-BY) Katja Schulz
Downy Woodpecker (CC-BY) Fyn Kynd
Bullfinch (CC-BY) Kev Chapman
Yellow-Tufted Woodpecker (CC-BY) Joao Quental
Japanese Tiger Beetle (CC-BY) *Coniferconifer*
Bluetit (CC-BY) Ian Preston
Lined Leaf-Tailed Gecko (CC-BY) Frank Vassen
Yellow-Throated Toucan (CC-BY) Becky Matsubara
Fan-Throated Lizard (CC-BY) Yogendra Joshi
Zebra Banded Dartfish (CC-BY) Brian Gratwicke
Panther Chameleon (CC-BY) *Kuhnmi*
Galápagos Lava Lizard (CC-BY) *Kuhnmi*

CoachwhipBooks.com

400+ Titles Available

www.ingramcontent.com/pod-product-compliance
Lightning Source LLC
Chambersburg PA
CBHW040107180526
45172CB00009B/1260